D0218381

Excavating Voices

LISTENING TO PHOTOGRAPHS OF
NATIVE AMERICANS

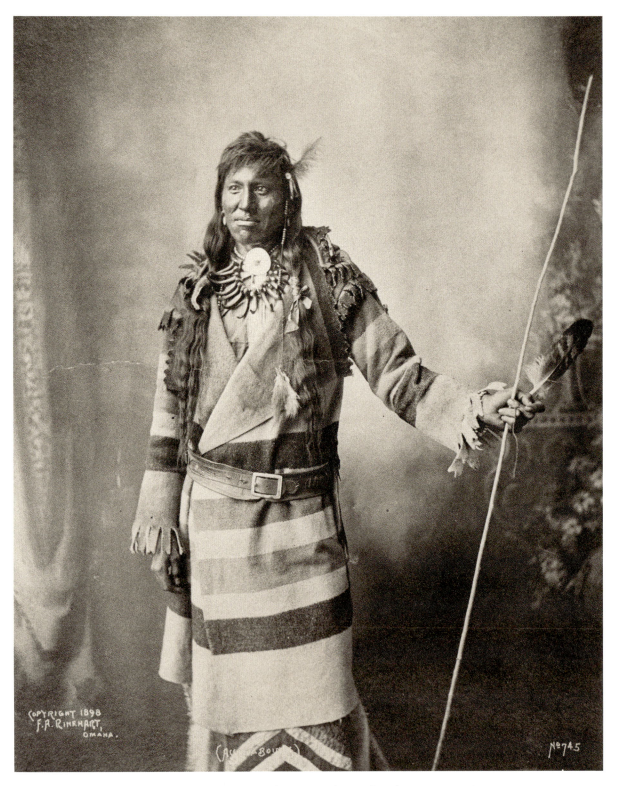

Assinaboines. *F. A. Rinehart, Omaha, Nebraska, 1898 (#745).*

Excavating Voices

LISTENING TO PHOTOGRAPHS
OF NATIVE AMERICANS

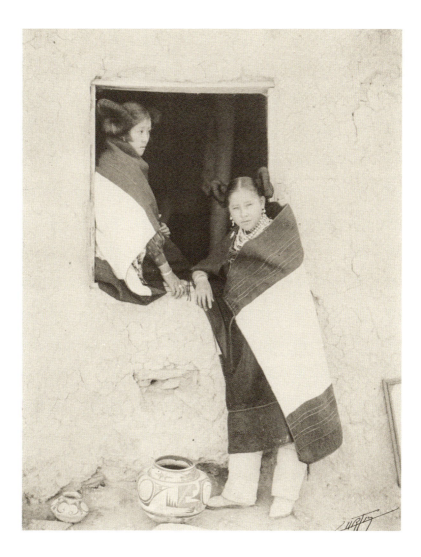

Edited and with an introduction by Michael Katakis

UNIVERSITY OF PENNSYLVANIA MUSEUM
of Archaeology and Anthropology

9

TR
681
.T58
E93
1998

Photographic Prints: Robert Asman, Philadelphia
Design and Production: Bagnell & Socha, Bala Cynwyd, PA
Printing: Piccari Press, Inc., Warminster, PA

Library of Congress Cataloging-in-Publication Data

Excavating voices: listening to photographs of Native Americans /
edited and with an introduction by Michael Katakis.

 p. cm.
 ISBN 0-92-417156-1 (cloth)
 ISBN 0-92-417157-X (pbk.)

 1. Indians of North America—Portraits. 2. Portrait
photography—United States—History. 3. Photography in
ethnology—United States—History. I. Katakis, Michael. II.
University of Pennsylvania. University Museum of Archaeology and
Anthropology.
 E89 .E9 1998
 973.04'97'00922—ddc21

 98-19691
 CIP

Copyright © 1998
University of Pennsylvania Museum
All Rights Reserved
Printed in the United States of America

Contents

List of Photographs

Acknowledgments

Books are seldom completed without the talents and inspirations of others and this volume is no exception. I would first like to thank Karen Vellucci, of University Museum Publications, for her steadfast belief in this project and for her kind, courteous, and constructive counsel. Many thanks go to Alessandro Pezzati who, with good humor and much professionalism, walked me through the University of Pennsylvania Museum's photographic collections and endured hours of my making new negatives. A large thank you also is owed to Mr. Robert Asman who did all the photographic printing for this book. To Kris Hardin, who always had time to listen, suggest, and encourage on this and other works, my heartfelt appreciation.

Professor Robert Preucel allowed me to lift his original essay title for this book. His sacrifice has made for a more handsome volume and it is appreciated greatly by this editor.

Author William Hjortsberg patiently listened to my essay and made comments on the writing for which I am indebted. My assistant, Kelly Drum, patiently typed and retyped my drafts with care and suggestions.

Lastly I would like to thank Professor Gerald Vizenor for our many conversations and the sharing of his insights.

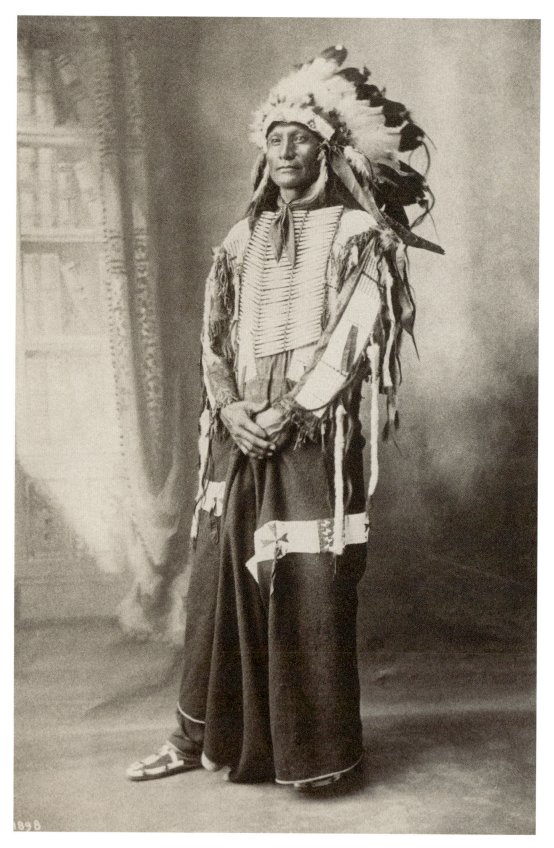

"Chief Goes to War (Sioux)." *F. A. Rinehart, Omaha, Nebraska, 1898 (#764).*

The Illusion of
the Image

BY MICHAEL KATAKIS

"Like the state, the camera is never neutral."

John Tagg

OR NEARLY TWO YEARS I HAVE BEEN looking at these photographs and they have come to haunt me, not because of what I see, but by what I don't, and possibly can never, know. As I've stared into these faces, I have tried to get beyond what is obviously the photographer's directions to 'sit here' or 'look at me', 'turn to the light' or 'wear this', and I have failed. I have tried to scale the mountains of commerce and myth, of museum-speak and scholarship and Hollywood and the media, all of which have, to some degree, reduced these people's lives to commodity, and again I have failed. I cannot seem to get into their eyes or hearts. I wish to go farther than the image paper will allow.

As a photographer, I know well the limitations that early documentarians had, such as glass plates and unstable chemicals. They could not capture life moving, so they stopped it and then constructed a world in their studios and in the field that often used

Native Americans as props in the photographer's presentation of what an "Indian" is. The portraits have come to tell me more about the photographers and the times they lived in than the subjects themselves.

Like many people, I have been influenced by the languages of sociology, anthropology, and museums, and yet, with all the explanations and examples, I find that I am still hungry—hungry to reduce all the big analyses into small pictures of individual lives. The "experts" have tried to make me believe that this is unnecessary. "Just read my book," they say. I do and am still hungry. "See this film or hear this lecture or visit this museum." I do, and I am still hungry for the people in the photographs to tell their own stories. This is the piece of the puzzle that has been missing for so long, and it must be a very important piece, because for decades, their voices have been purposely excluded.

It has been said that a picture is worth a thousand words, but I have often wondered if those words are fiction or non-fiction. If you believe, as I do, that the camera is never neutral, then you can never take a photograph at face value. Both the creation and the interpretation of photographs are dictated, in part, by the intricacies of personal experience and bias.

Political and market forces also play a role in the creation and interpretation of photographs. In need of cash for his monumental project, *The North American Indian*, Edward Curtis approached publishers to print his photographs and help defer the costs of his continuing work. One publisher responded with an analysis, not of Curtis's work, but of the marketplace: "The market's full of 'em. Couldn't give 'em away."[1]

As Laurie Lawlor considers in her book, *Shadow Catcher*, we must remember that when Curtis first began documenting and trying to understand Native American cultures in the late 1800s, academics and their institutions sat on the sidelines. Lawlor says of Curtis: "He sought to observe and understand by going directly into the field. He worked tirelessly to gather information that many academics during this period had neither the skill, interest, nor courage to collect. Curtis's commitment helped ensure that knowledge of many early tribal ways of life was not lost forever." Curtis's photographs are romantic and beautiful, and reflect his view of Native Americans as a noble people.

Photographs such as those taken in the field by Curtis generated a new interest in the "Noble Savage" among people in Eastern cities of the United States who saw the early photographs. Museums and academics did finally get involved in the documentation process, but only when men of letters and, more importantly, men of great wealth showed an interest in the work. As museums and academics began studying Native

American cultures, they moved to control the presentation of Indian cultures to the American public. Although these institutions suggested a degree of scholarly objectivity, it is clear they had their own agendas, often having to do with fund raising as much or more so than with education. They used the images of photographers like Curtis in their "scientific" presentation of Indian cultures, but they also needed to push out people like Curtis in order to centralize their authority over the presentations and the research enterprise. In 1907 Teddy Roosevelt, who had supported and encouraged Curtis's early work, cautioned him that important academics were questioning his work. What was his background, they asked, and was he using "scientific" methods.[2] Professors in the field of anthropology knew that Curtis had received financial help from John Pierpont Morgan and the support of people like Theodore Roosevelt, and they sought to solicit those kinds of sponsors and funds for their own purposes. To discredit those outside the academy was to send a message that still exists today: truth, science, and objectivity reside only in the museums and hallways of academe. It must be remembered that when many academics finally went into the field the polite phrase "gathering of artifacts" was really the appropriation of personal property by the group with the most power. If one of these white scholars had done the same thing to their neighbor in Boston or New York, it would have been called looting or armed robbery.

In spite of their differences, what tied photographers, journalists, museums, and scholars of that time together was power and the ability to deny Native Americans their own voice. Even the well-meaning, like Curtis and other photographers represented in this volume, innocently helped perpetuate the myths and stereotypes of Native Americans that still haunt us today—the noble savage, the monolithic group. We do not glean from these early photographs a sense of Native Americans as individuals with dreams, hopes, sorrows, even flaws. Instead, they serve as props for the viewer's imagination, clouded as it is with the myths presented by a previous generation of photographers and scholars.

As a society, we form our views and opinions from the words and photographs of others. That's what history is all about, but one must always ask who took the photographs, who wrote the words, and why. We must always ask who controls the recording of particular histories. As a boy I loved U.S. history. I never stopped to think that these were people like me with dreams and hopes or that Native Americans might have had a real grievance against the United States government. Broken treaties and genocide were not in the history books I read. Why would they be? The writers of those histories were all white men. No Native American voices were included. Histories

have most often been formed by the illusions, interests, and hopes of their makers. In the last decade we have come to recognize that real power lies not merely in telling history your way, it also includes the power to silence other voices, to deny their insights into historical events.

It would be a mistake to think the power to silence is something from the past. It is alive and well today and continues to support a previous generation's mythic view of Native Americans in the guise of political correctness. When I chose the cover of this book, an individual from an eastern academic institution suggested that the photograph denigrated Native Americans; neither a scholar nor a Native American, their position in the institution still gave them influence over the ways some institutions represented Native Americans. Concerned, I began to contact Native Americans from different nations. None found the picture offensive. One individual told me this picture was probably taken of a Native American visitor to an eastern city. Often these Indian visitors were taken on a tour of landmarks in the cities they visited. Sometimes a guest would be taken to a department store. The individual pictured on the cover probably saw these motoring goggles, bought them, and wore them to the photography session, much the way anyone might wear something new with pride. In other words, it is safe to assume that, given the time and the inclination of photographers to show Native Americans as wild, noble, and savage, it was actually the subject's own decision to manipulate the format by wearing the goggles, thus taking some control over the way he was represented. Objecting to this photograph, however well-meaning, demonstrates a paternalistic protectionism toward Native Americans that is yet another mechanism for silencing and for denying the choices they might make. At the same time, it reinforces stereotypes of the "noble savage," which itself was constructed from images like those of Curtis, with his goal of showing the nobility of Native American life. In fact, many of us probably interpret the cover photograph as "humorous" precisely because it works against our view of the "nobility" of the Native American and makes us slightly uncomfortable.

This is the way myths are made. Once made, myths, like turf, must be defended, or those in power (those making the myths) will see a portion of their power and control diminished. I know well that everyone carries with them their biases, life experiences, and histories. Try as people will to exorcise these factors, the subconscious still retains them. I would suggest there is great freedom in pulling aside the curtain of presumption and expertness and revealing the magic of not knowing. We do not come to the end of knowledge, for it is always being discovered and revised, amended or

discarded as we venture farther, learning new things. My father once told me that a truly educated man was one whose mind was always poised to change based upon the evidence. We should all be wary of any institution or individual that has embraced dogma and self-interest over ideas, does not allow free criticism of itself, or does not engage in honest and open debate. Without these frictions and arguments there is no education. We should always be suspicious of anything or anyone claiming to know the truth, be it picture, exhibition, newspaper, or speech. Equally, we must keep in mind that what we take as truths are often constructions that have to serve many masters.

As for me, I take Gerald Vizenor's advice when I look at these photographs. I focus on the eyes. In some of the pictures the eyes are dead; in others, painfully fatigued; and yet it appears that some are remembering—maybe the time before the great circle was broken. A time when they were free. After seeing them for so long I have, finally, more questions than answers. I look into their faces and see a people like me and not like me. I know well that they had their own dreams and religions and ways; I know that they understood what was gone, forever.

For those lost in memories, perhaps memory itself was the final defiance, the one thing the conqueror could not have, could not control.

That's what I see. What do you see? Why?

—Bozeman, Montana 1997

NOTES

1. Laurie Lawlor, *Shadow Catcher: The Life and Work of Edward S. Curtis.* (New York: Walker and Co., 1994); p.54.

2. Lawlor, p. 73.

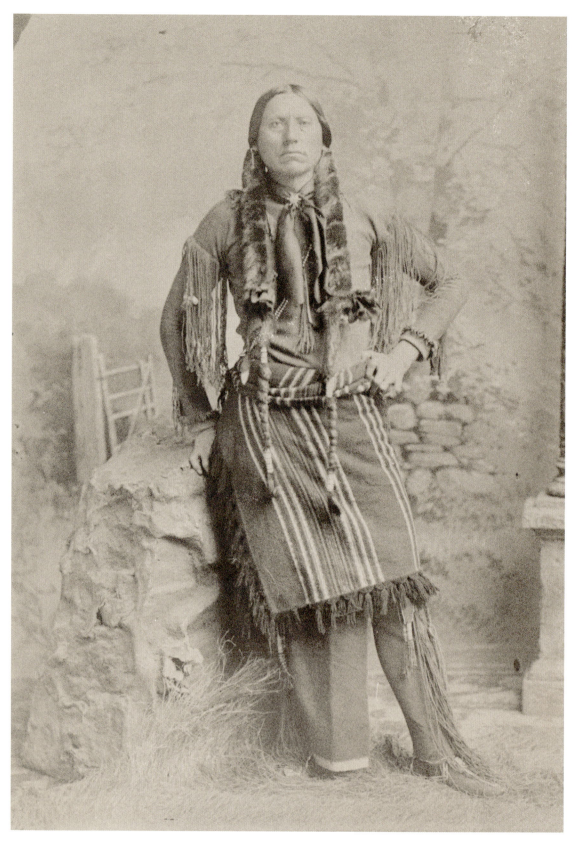

Quanah Parker. *C. M. Bell, Washington, D. C., 1880s.*

Fugitive Poses

BY GERALD VIZENOR

THE NOTION THAT A PHOTOGRAPH IS worth a thousand words is untrue in any language. Narratives create that sense of presence in photographic simulations, but even stories can be separations when they serve the manners of unbidden dominance. Photographs are specious representations, the treacheries of racialism, neither cultural evidence nor the shadows of lost traditions.

Native American Indians sensed the solace and mythic chance of their memories in narratives, not cameras. The tribes posed in silence at the obscure borders of the camera; fugitive poses that were secured in museums. The silence could have been resistance, never an eternal pose without humor; however, the photographic representations of the tribes became the evidence of a vanishing race and the assurance of dominance.

What can we *see* in the photographic representations of the racial other that is not dominance? Portraiture as evidence, or even *postindian* pastiche, must be more than the eternal silence of fugitive poses; there, in the stare of the shadows, is an elusive tribal presence. The true stories of pictures are in the eyes, not in the costumes or simulations of culture; the eyes are the tacit presence, the costumes are the racial enactments of the other. Clothes, masks, and decorations are changeable, and borrowed clothes are prosaic simulations, neither cultural codes nor representations of conversion stories. The eyes that meet in the camera are the assurance of narratives and presence.

"What is the content of the photographic message? What does the photograph transmit?" asked Roland Barthes in *Image—Music—Text*. "Certainly the image is not the reality but at least it is its perfect *analogon* and it is exactly this analogical perfection which, to common sense, defines the photograph. Thus can be seen the special status of the photographic image: it is a message without a code . . . "

What could the absence of a code that has a message of racialism and dominance mean in portraiture? The destinies of the nation are burdened with racial simulations and the captious warrants of civilization; at the same time, there is incontrovertible evidence of the actual removal and termination of real tribal communities. The camera became a new weapon in the representations of manifest manners. The fugitives of dominance learned how to pose is silence as an act of survivance.

John Tagg pointed out in *The Burden of Representation* that the camera has the power of surveillance and representation. "Like the state, the camera is never neutral. The representations it produces are highly coded, and the power it wields is never its own."

Photographs are never worth the absence of narratives because languages are imagination and photographs are the simulations of closure. Tribal poses are the eternal fugitives of the camera; the decorated poses, captured and compared, are the public evidence of dominance, not the private metaphors of courage or the clever stories of an uncertain tribal nature.

"When we are afraid, we shoot. But when we are nostalgic, we take pictures," wrote Susan Sontag in *On Photography*. "Still, there is something predatory in the act of taking a picture. To photograph people is to violate them, by seeing them as they never see themselves, by having knowledge of them they can never have; it turns people into objects that can be symbolically possessed."

The pictures of the tribal other, the wounded fugitives of the camera, are not the same as those nostalgic photographs of homesteaders and their families in a new nation. The manifest camera created fugitive poses that separated tribal communities from their ancestral land; the simulations of the other turned the real into the unreal with no obvious presence in time or nature. For these reasons, and more, the tribal other in photographs should be seen in the shadows of the eyes, an honorable invitation to underived narratives rather than public representations and closure.

Native American Indians have been eye to eye with occidental predation and the ironies of civilization for more than five centuries. The same nations that celebrated political and religious liberties embraced racialism, treacherous objectivism, and master evidence over the humor of creation, natural reason, and the wisdom of tribal families.

The eyes of the wounded fugitives in photographs are the sources of stories, the traces of tribal survivance; all the rest is ascribed evidence, the representations of dominance. The eyes have never been procured in colonial poses, never contrived as cultural evidence to serve the tropes to institutional power.

The eyes are the narrative presence of the tribes, and the poses are the simulations of the other, the unreal representations of the other as causal evidence of *Indianness*, the state, conditions, and instance of simulations as the real; at the same time, the simulations are ironies because even the fugitive poses of the other are overcome by the wicked closure of savagism and civilization.

Closure is another name for the nescient representations of the other, and in this sense, the extreme closure of *Indianness* in photographs. "Representation is what determines itself by its own limit. It is the delimitation for a subject, and by this subject, of what 'in itself' would be neither represented nor representable," wrote Jean-Luc Nancy in *The Birth to Presence*. "But the irrepresentable, pure presence and pure absence, is also an effect of representation . . . "

The eyes are the narratives not the ruins of tribal bodies. "Photographs in themselves do not narrate. Photographs preserve instant appearances," wrote John Berger in *About Looking*. The eyes in a photograph are the secret mirrors of a private presence, not the closure of public representations; indeed, the eyes hold the presence of the photographer on the other side of the aperture. The instances of the eyes in the aperture are continuous narratives that counter the closure of discoveries and cultural evidence in photographs.

Jean-Luc Nancy argued that the "body first was thought *from the inside*, as buried darkness into which light only penetrates in the form of reflections, and reality only in the form of shadows." Literature mimes bodies, and bodies are shadows, and the shadows become representations in photographs. "The body is but a wound," he wrote in *The Birth to Presence*.

The eyes are the secret stories of wounded bodies, and the poses are the absence of the other, an ironic exposure because the representation of bodies as cultural evidence is the certain death of the other, death by photographic exposure.

"Whatever it grants to vision and whatever its manner, a photograph is always invisible: it is not it that we see," wrote Roland Barthes in *Camera Lucida*. The eyes, in this sense, are the presence we see in photographs. "Every photograph is a certificate of presence. This certificate is the new embarrassment which its invention has introduced into the family of images."

Quanah Parker, for instance, is pictured in both tribal clothes and in a morning coat with an umbrella, pocket watch chain and derby. In one photograph he is supported by a rustic wall, in the other by a classical stucco simulation. He is posed near the same ornate column in both photographs. These could be fashion pictures of a tribal fugitive; indeed the obscurities of modes and costumes could be a must better interpretation of tribal histories than the rush to cultural evidence.

The costumes in photographs are not the same as either real clothes, ceremonial vestments, or the languages of clothes and fashions, because the stories of each appearance are never the same as the simulations of *Indianness*. Costumes are the seasons, the fashions and measures of time; the species of costumes in pictures are not the monotheistic closure of creations.

Parker was Comanche, a wise crossblood leader at the turn of the last century who defended the use of peyote as a religious freedom. The narratives of his religious inspiration, his crossblood uncertainties, are not obvious in either of the photographs. His hair is braided in both pictures but the poses seem to be the causal representations of then and now, tradition and transition, or variations on the nostalgic themes of savagism of civilization. His eyes, not the costumes, are the narratives, his presence in the picture; his eyes are the sources of imagination, not the mere notice of an umbrella, a derby, or bound braids. His eyes are the presence of the pictures; the stories of resistance, and traces of tribal survivance. His eyes dare the very closure of his own fugitive poses.

Quanah Parker was an inspiration to the tribal people of the plains. "The great warrior established his bravery when he and a group of Comanches refused to accept the dictates of the Treaty of Medicine Lodge and battled to the end at Adobe Wells in Texas in 1874," wrote Rennard Strickland in *The Indians of Oklahoma*. "Parker then led his people down the new road, became a famous tribal judge, and as a member in the Native American Church was a widely identified peyote figure. While willing to adjust to farming and the new economic ways, Parker continued to practice the old Comanche family way of having a number of wives. Ironically, while Parker remains to the present a controversial figure in his own tribe, the Parker pattern of selective adaptation and resistance became the one Oklahoma's Indians generally followed."

The decorative feathers, beads, leathers, woven costumes, silver, turquoise, bone, and other tribal representations have turned humans into the mere objects that bear material culture in photographs. Moreover, peace pipes, medals, trade axes, bows and arrows, rifles, and other weapons, are the obscure simulations of *Indianness*. The tribal

other is seldom pictured with families, children, or in situations of humor and chance. Most photographers of the tribes focused on the fugitive warrior pose and decorative costumes as traditional, the occidental simulations of *Indianness*; such closures of presence would be mimicked several generations later by postmodern tribal leaders as the traditional sources of radical identities. The imitations of the fugitive poses are the double closures of presence, an ironic separation with no wisdom or sense of the real; the fugitive remains are the perpetual victims of dominance.

Edward Curtis, for instance, one of the most dedicated pictorial photographers of Native American Indians, altered some of his photographs to preserve the fugitive poses of tribal traditions. Some of these poses have become the evidence of traditions in the new simulations of urban *Indianness* and *postindian* identities.

Curtis removed umbrellas, suspenders, the tracks of civilization, and any traces of written languages. This was unfortunate because at the turn of the last century thousands of tribal scholars had studied at federal and mission schools and were teachers on the same federal exclaves that photographers visited with their costumes and cameras. Curtis was the best of the portrait photographers, to be sure; nevertheless, his portraits enhanced the image of the noble savage as the antithesis of civilization. He visited hundreds of tribal communities and processed more than forty thousand pictures that simulated *Indianness*. Alas, his dedication proved that ethnographic photography is an oxymoron. The last aversions, however, are overturned with the evidence of new simulations.

Russell Means and others have mastered the oxymora, the *postindian* simulations of ethnographic portraiture. He posed with radical leaders of the American Indian Movement at the occupation of Wounded Knee, secured several roles in motion pictures, and a studio production of a silk screen portrait by Andy Warhol.

Native American Indians were simulated in portraiture generations before the invention of photography. George Catlin, Karl Bodmer, Charles Bird King, and others, have been praised for their exotic and ethnographic portraits of the tribes. King recorded personal names with most of his portraits, but the ethnic noses and costumes were homogenous; other painters created innominate ethnographic simulations. The tribal persons in most portraits and photographs became mere ethnographic simulations, silenced without names or narratives; the pictures were the coincidence of discoveries and the causes of dominance.

Richard Brilliant pointed out in *Portraiture* that the notions of ethnographic portraits "seems to cause some critical difficulty in assessing their worth as portraits

because the subjects are so often ignored as subjects of portraiture or they are strongly subordinated to other agendas of representation." The other is the simulation of ethnographic portraiture. "Of course, portrait artists working in their own culture rarely think like ethnographers, nor is it customary to apply anthropological techniques to the portraits of those with whom one shares a common culture." Ethnographic portraiture is an oxymoron of dominance.

"The photograph both loots and preserves, denounces and consecrates. Photography expresses the American impatience with reality," Sontag argued in *On Photography*. "After the opening of the West in 1869 by the completion of the transcontinental railroad came the colonization through photography. The case of the American Indians is the most brutal." Tourists invaded the privacy of the tribes, "photographing holy objects and the sacred dances and places, if necessary paying the Indians to pose and getting them to revise their ceremonies to provide more photogenic material."

The public at the time was most interested in the warriors who had fought the soldiers that in the new tribal historians, artists, and medical doctors. The first photographers worked for the railroads, the military, or government surveys; their pictures of the plains tribes, the Sioux and Comanche in particular, "helped create the image of an Indian in a long headdress, made so familiar later by Hollywood films," wrote Dorothy and Thomas Hoobler in *Photographing the Frontier*. "Studio photographers went so far as to keep on hand what was regarded as 'typical' Indian dress to supply to Indians who might otherwise come to be photographed in nondescript, more practical attire."

What might have been the watchwords of the entrepreneurs on the other side of the camera? Hundreds of photographers created simulations that would menace the tribes for more than a century, but the men armed with cameras were seldom burdened in tribal communities. How were the others in the aperture to know that the pictures of them would be possessed as cultural evidence, sold as postcards, and established in new museums as representations of tribal traditions? Only mythic ironies and an incredible watchword could touch the obvious contradictions in the occidental obsession to render the tribal other unreal in their own natural time and place.

How would these photographers of *Indianness* explain the distinctions between public and private simulations of the other? Clearly there are more serious troubles to consider, but remember the eyes, and the stories that the loss of privacy is the loss of freedom. Photographers abused the tribal sense of privacy, and then either sold or distributed the simulations to various agencies. How should we now respond to the photographs that violated the privacy of the subjects?

Does aestheticism absolve those who inherited their dominance in the celebration of the arts? The automation of new cameras recreates an aesthetics of treasonous innocence. The video simulations of the tribes, for instance, are the most recent fugitive poses in motion; the noble savages of past portraiture have become the noble victims of television simulations. Nonetheless, the eyes are the shadow presence, and the eyes of the photographer in the aperture are forever in the narratives of the pictures.

"Privacy is usually considered a moral interest of paramount importance. Its loss provokes talk of violation, harm, and loss of agency," wrote Julie Inness in *Privacy, Intimacy, and Isolation*. "Privacy is defined as a variety of freedom, a freedom that functions by granting the individual control over the division between the public and the private with respect to certain aspects of life." Tribal privacy and freedom were seldom considered in the simulations of the other; the representations of the tribes in photographs were the sudden closure of the rights and liberties to privacy. The picture of the nude, for instance, is abused as a postcard, an ironic tease in a culture that associated nude bodies with savagism.

Those who discover the other in pictures, *Indianness* in the absence of the real, have denied their own presence in the histories of representations; moreover, the tribes must bear the treacherous simulations of dominance. Otherwise, the curious other in the aperture could be seen as an aesthetic closure in the new stories of tribal presence.

"The only thing left for me to do is to find a refuge in the *other* and to assemble-out of the *other*," wrote Mikhail Bakhtin in *Art and Answerability*, "the scattered pieces of my own givenness, in order to produce from them a parasitically consummated unity in the *other's* soul using the *other's* resources. Thus, the spirit breaks up the soul from within myself."

The most obvious search for the other is in the simulations of *Indianness*; the eyes are narratives in the same aperture, and the closure of the representation is the evidence of the other. The photographer has presence in the eyes of the subjects that are absent in his photographs; the other is an ironic representation of the photographer. "The *I* hides in the other and in others, it wants to be only an other for others, to enter completely into the world of others as an other, and to cast from itself the burden of being the only *I* (*I-for-myself*) in the world," wrote Bakhtin in *Speech Genres and Other Late Essays*.

Native American Indians have practiced medicine, composed music and poetic narratives, won national elections, and traveled around the world before the turn of the century, but their experiences were discovered as the other, the antithesis of civilization

in photographs and motion pictures. The simulations of the other in pictures, in fact, continue to be an established bourgeois source of notions about *Indianness*; the absence of the real, the simulations of the unreal, have become the historical evidence of *Indianness*. the ersatz tribes over their actual presence.

"More than any other medium, photography is able to express the values of the dominant social class and to interpret events from that class's point of view, for photography, although strictly linked with nature, has only illusory objectivity," wrote Gisèle Freund in *Photography and Society*. "First catering to the intellectual elite, photography next reached out to the bourgeois middle class. But when commercial photographers made pictures to please an uneducated public, even the initial supporters of photography became vehement critics."

The fugitive poses in simulations are the eternal critics of photography; all the more vehement because the simulations of *Indianness* have overturned the real presence of the tribes. Watch the shadows of the eyes to hear the narratives of a continuous presence.

—Gerald Vizenor
University of California
at Berkeley

REFERENCES

Mikhail M. Bakhtin, *Art and Answerability: Early Philosophical Essays.* trans by Vadim Liapunov. (Austin: University of Texas Press, 1990).

Mikhail M. Bakhtin, *Speech Genres and Other Late Essays.* (Austin: University of Texas Press, 1986).

Roland Barthes, *Camera Lucida: Reflections on Photography,* trans. by Richard Howard (New York: Noonday Press, Farrar, Strauss and Giroux, 1981).

Roland Barthes, *Image—Music—Text,* trans. by Stephen Heath (New York: Hill and Wang, 1977).

John Berger, *About Looking.* (New York: Pantheon Books, 1980).

Richard Brilliant, *Portraiture.* (Cambridge, Mass.: Harvard University Press, 1991).

Gisèle Freund, *Photography and Society.* (Boston: D. R. Godine, 1980).

Dorothy and Thomas Hoobler, *Photographing the Frontier.* (New York: Putnam, 1980).

Julie Inness, *Privacy, Intimacy, and Isolation.* (New York: Oxford University Press, 1992).

Jean-Luc Nancy, *The Birth to Presence.* (Stanford, Calif.: Stanford University Press, 1993).

Susan Sontag, *On Photography.* (New York: Farrar, Strauss and Giroux, 1977).

Rennard Strickland, *The Indians of Oklahoma.* (Norman: University of Oklahoma Press, 1980).

John Tagg, *Burden of Representation: Essays on Photographs and Histories.* (Amherst: University of Massachusetts Press, 1988).

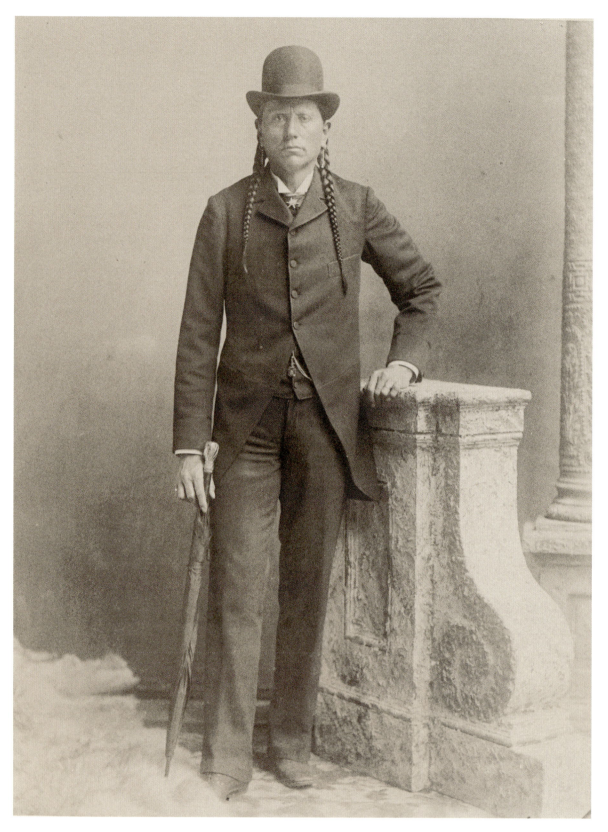

Quanah Parker. *C. M. Bell, Washington, D. C., 1880s.*

Learning from
the Elders

BY ROBERT W. PREUCEL[1]

T HESE PHOTOGRAPHIC IMAGES OF
the indigenous peoples of North America whom we mistakenly call Indians
speak to us in a multitude of voices. The loudest of these are the voices of
Manifest Destiny, progress, and industrial capitalism—voices that have both defined and
controlled the ongoing conversation between native peoples and whites. They require
our attention, not because of the truths they proclaim, but because of those they
conceal. By listening to these voices, we can learn just how deeply our own history is
intertwined with the histories of Native Americans.

When photography was invented in 1839, it dramatically transformed the popular
understanding of the world.[2] The photographic image reproduced "Reality-as-it-was"
and displayed it in black-and-white for all to see. Subjectivity was no longer an issue,
and, almost overnight, the Native American portraits of George Catlin and Karl
Bodmer were rendered obsolete. But this clarity was, of course, false clarity, and the
photographic representations were, at best, only partial or half truths. The early
photographers who experimented with this new medium were quick to appreciate this
new power of representation and found ready employment in manufacturing images of
Native Americans as exotic and foreign, as peoples against whom society could measure
its progress and sophistication.

The first photographers of Native Americans were professionals, such as William Henry Jackson and John Hilliers, who accompanied surveys of the American West after the Civil War. In this context, native peoples were depicted as part of Nature, denizens of a vast new landscape with abundant resources waiting to be exploited in the inexorable westward push of civilization. Later, photographers such as Edward S. Curtis and Frank A. Rinehart began to construct images of Native Americans emphasizing nobility in an appeal to Romantic sensibilities. Still others, such as Charles Bell and John Nicholas Choate chose to document the "domestication of the savage" thereby reassuring a new nation of the superiority of its beliefs and culture, and denying native peoples any active role in managing change and successfully defining their own identities. The public popularity of these images, distributed as cabinet cards and book illustrations, thus disguised the politics of representation.

But if we listen more carefully, we can begin to hear softer voices, voices varied in tone and accent which transcend the intent of the photographer and speak with an authority grounded in tradition and experience. These voices are the voices of native peoples themselves. They remind us that they have not disappeared, that they are all around us—living and working in cities and on reservations, at colleges and universities, in state legislatures and Congress. They invite us to learn from their stories and to appreciate their multiple truths.

RHETORIC

Since the formative days of our Nation, and up to and including the present, the so called "Indian question" has been debated in and around two arenas of discourse. The first of these is the arena of government policy and the second the arena of public opinion. There is, of course, a connection between these two arenas—our government is held to be accountable to public opinion. But, in fact, this relationship is quite fluid, ever changing, and never completely articulated. And because of this movement, there is always a space between the two. This space is the site for defining new visions for the future of our country and the place for resistance to existing government policies.

The official language of this discourse shows a deep ambivalence about the status of "the Indian," and this was expressed by dramatic policy oscillations between the polar extremes of assimilation and segregation.[3] Some, like Thomas Jefferson stated that all that was required for the Indian to become part of the American family was a Christian education. Others, like Andrew Jackson, felt that the Indian needed time for assimila-

tion, and since he was being corrupted by the vices of civilization, the only solution was to remove him to his own territory for his own good. Still others, like Commissioner of Indian Affairs Luke Lea, proposed that each tribe should be assigned a permanent home suited to agriculture and be provided with stock, agricultural tools, clothing, homes, and education. These views became codified in the policies of Missionization, Removal, and the Reservation System.[4]

This ambivalence is mirrored by changing views of Native American identity as expressed in popular sentiment. One of the most prevalent images was that of the "Noble Savage." This view, already old when Jean Jacques Rousseau took it up, alluded to a past Golden Age marked by innocence and contentment.[5] Philip Freneau, one of the most famous of the nineteenth-century poets on Native Americans, regarded the Indian as the primeval "child of Nature," who could teach civilized man "one great Truth."[6] This romantic view was tempered by that of the "Bloodthirsty Red Devil" put forth by white settlers bent on carving out their homesteads and farms. Here this image can be seen as the antithesis of Noble Savage, the fallen Indian, who had become contaminated by exposure to corruptive influences of whites.

But both of these images sprang from one master image, that of the "Vanishing Race." This image is perfectly embodied in James Fenimore Cooper's *The Last of the Mohicans*. In his introduction, speaking of the dispossession of the Delaware (Lenape), he wrote of the "seemingly inevitable fate of all these people, who disappear before the advances or, it might be termed, the inroads of civilization."[7] Here the fate of a specific group has been generalized to an entire people according to the presumed scientific law of evolutionary progress, that civilization always and inevitably supersedes savagery. This view persisted as late as 1938 when John Collier, the Commissioner of Indian Affairs, observed that "[f]or nearly 300 years white Americans, in our zeal to carve out a nation made to order, have dealt with the Indians on the erroneous, yet tragic assumption that . . . [they] were a dying race."[8]

The twin notions of the Noble Savage and the Vanishing Race directly stimulated Edward S. Curtis's monumental photographic survey of the American Indian. In his forward to Curtis's work, Theodore Roosevelt wrote,

> The Indian as he has hitherto been is on the point of passing
> away. His life has been lived under conditions through which our
> own race passed so many ages ago that not a vestige of their

memory remains. It would be a veritable calamity if a vivid and truthful record of these conditions were not kept.[9]

But Curtis only depicted a certain kind of Indian. As he says in his Introduction, his work was "a comprehensive and permanent record of all the important tribes . . . *that still retain to a considerable degree their primitive customs and traditions.*"[10] For him the authentic Indian was the Indian unsullied by contact with civilization. This then is how we are to understand his photographs of the "Taos Water Girls," "At the Old Well at Acoma," and "The Rush Gatherer—Kutenai."

The image of the Vanishing Race also explains the immediacy underlying the experimental programs in Indian education. In 1879 Captain Richard Pratt established an Indian School at the site of an unused military barracks at Carlisle, Pennsylvania. His philosophy was deceptively simple: to transform Indian children into American citizens through education. He wrote, "I suppose the end to be gained, however far away it may be, is the complete civilization of the Indian and his absorption into our national life, with all the rights and privileges guaranteed to every other individual, the Indian to lose his identity as such, to give up his tribal relations and to be made to feel that he is an American citizen."[11] Pratt, an ex-superintendent of the prison at Fort Marion, Florida, ran his school along strict military lines. Here we see two photographs of a Navaho boy, Tom Torlino, taken by John Nicholas Choate, the official photographer of the school. One photo shows Tom with long hair and wearing traditional dress upon his arrival in 1882 and the other shows him three years later with his hair neatly shorn and wearing a broadcloth suit.[12] These "before and after" photographs were used by Pratt as a propaganda tool, a visual testimony of the success of the school and the superiority of civilization.[13]

VENTRILOQUISM

Regardless of the specific policy in effect, both political and popular views concurred in the fact that Indians were childlike, unable to make their own decisions, and in need of government protection. They required a guardian to speak for them. The justification for this ventriloquism is contained in the statement by James C. Mitchell to the 20th Congress on December 18, 1827.

> Shall we not act with the same caution toward these children of
> the forest that we would with the miserable suicide? Is it our duty

to consult their will in such a matter? . . . These poor beings are incapable of understanding their own true interest, or choosing what will be most to their benefit. Let us act for them . . .[14]

The new media of photography created new political and economic opportunities for the "speaking for others." The duality of photographic realism allowed professional photographers to make statements which had little basis in the social existence of native peoples and everything to do with the desires and demands of a public hungry for romance and violence. Accordingly, photographers produced images which subsumed individual and tribal identities under the generic racial rubric of "Indian." To produce these images, they made wide use of photographic techniques as well as theatrical sets complete with false backdrops, stock costumery, and stage props.

Stereotyping of this sort can be seen in John Hillier's Mescalero Apache series. Hilliers was the photographer for Major John Wesley Powell's second expedition down the Colorado River and later became a distinguished photographer for the U. S. Geological Survey and the Bureau of American Ethnology.[15] In these studio photos, Hilliers has staged an outdoor portrait complete with a local rock outcrop and given his subject different props—a bow and arrow, a pipe and pipe bag, a hairbone breastplate, and a peace medal. In each photo, an unidentified Apache man is dressed in plains style breechcloth, leggings, and moccasins. The effect of this costume is to mask what is distinctive about Apache identity and culture and to emphasize the stereotypical symbols of Indianness. Personal, family, and tribal identities are thus only names; what really matters is race. This kind of postcard photograph became widely popular among the American public.

Another more subtle example of manipulation can be seen in the work of Charles M. Bell, an official photographer of the Indian delegations to Washington D. C. Typically, Bell took a group photograph of the delegation as well as a series of individual portraits of important leaders. The differences between these two kinds of photographs reveal just how carefully native images were constructed. For example, in his depiction of the Oglala delegation, Bell shows Red Cloud dressed in a western suit, worn out of respect to Ulysses S. Grant, the President of the United States. But because these clothes could be misread as evidence of passivity and the acceptance of civilization, Bell has chosen to pose Red Cloud in the sitting portrait in a beaded war shirt and breast-plate. But these items of clothing do not belong to Red Cloud; they were borrowed from Little Wound, another member of the delegation, who is wearing them in the

official group photo. Here Bell is playing upon the notion of "Indianess," controlling the image of Red Cloud to read not as "civilized," but as "savage."

Edward S. Curtis is usually regarded as one of the most accurate of the professional photographers of Native Americans. Certainly he characterized himself in this manner. In his introduction to his grand opus *The North American Indian*, he wrote that, " . . . being directly from Nature, the accompanying pictures show what actually exists or has recently existed (for many of the subjects have already passed forever), not what the artist in his studio may presume the Indian and his surroundings to be."[16] In this case, Curtis is claiming that his concern for photorealism differentiates his work from that of the studio photographers, like Bell and Rinehart. His landscapes were real, not painted canvas; his subjects were caught amidst the activities of daily life, not artificially posed.

But as Christopher Lyman has shown, Curtis's own images are themselves skillfully manufactured.[17] Curtis often retouched his prints, painting out such objects of Western origin as wagons, umbrellas, and hats. He sometimes cropped out unwanted elements to focus attention on specific images, as is the case with one of his portraits of Chief Joseph. He commonly used different lenses and focal lengths to create specific moods. For example, the two Taos water carriers are half in shadow and slightly out of focus creating an air of mystery. And Curtis almost always posed his subjects to achieve the greatest dramatic effect. Here we see two Hopi girls wearing their finery posed in a window. This is not a scene from daily life. Curtis, however, considered this kind of manipulation to be permissible, because his ultimate purpose was to combine the artistic and scientific in documenting the "passing of the Indian."

Eloquence

But even with this speaking for others, the voices of native peoples transcend those of their portrayers. We can hear, for example, the voice of Red Cloud, the great Oglala leader, who from 1870 to 1897 made ten trips to Washington D. C. in order to negotiate for his beloved Black Hills. On his first trip, he made a powerful speech, of which this is an extract:

> The white children have surrounded me and have left me
> nothing but an island. When we first had this land we were
> strong, now we are melting like snow on the hillside while you
> are growing like spring grass. Now I have come to my Great

Father's house, see if I leave any blood in his land when I leave.
Tell the Great Father to move Fort Fetterman away and we will
have no more troubles. I have two mountains in that country
(Black Hills and Big Horn Mountain), I want Great Father to
make no roads through. I have told these things three times now.
I have come here to tell them the fourth time.[18]

This is not the speech of an innocent child. Indeed, Red Cloud has adroitly turned around the child metaphor by defining the white settlers themselves as children. If he is to be accountable to the Great White Father, then so too must they. What good are treaties when one side systematically refuses to enforce an agreement and control its own people? He also draws attention to the government's flagrant abuse of power by emphasizing the peaceful nature of his visit to Washington. He doesn't lead a war party to Washington but rather negotiates in good faith. But the settlers encroaching on his Black Hills repeatedly killed his people and refused to acknowledge the rights of the Dakota people. His is not the rhetoric of defeat but rather the rhetoric of justice.

We can hear the voice of Quanah Parker, the Cheyenne statesman, speak of the need for mutual respect and cooperation so that Indians and whites can coexist peacefully. During Parker's visit to Washington in 1895, Charles Bell portrayed Parker in both traditional garb and a businessman's suit. His intent is clearly to show Parker's progressiveness—the American Indian in his "natural state of savagery" has been transformed into the Indian American, a "peaceable law abiding citizen." In fact, Parker was in Washington as a representative of a consortium of white ranchers who were seeking to renew their leases on reservation land.[19] But this is only part of the story. Parker used the lease money, not to amass personal wealth, but to purchase cattle for the tribe and to hire attorneys to represent tribal interests. Despite the controversies among his own people about his allocation of money, Parker was no assimilationist; he was a strong defender of his people's religious freedom. In 1906, he led a delegation to the Oklahoma Constitutional Convention to protest the policy of dividing up Comanche County and to challenge the ban on the use of peyote in religious observances.

We can hear the voice of Juanita, the wife of the famous Navaho leader, Manuelito.[20] In December of 1874, she visited Washington D. C. as part of a Navaho delegation organized by Indian Agent, William F. Arny.[21] Earlier in the year, several Navahos had been killed by Mormons, and Arny used this event as an opportunity to alarm Washington that open warfare was immanent. Arny's real motive, however, seems

to have been a desire to negotiate a land deal by exchanging the northern portion of the reservation bordering the San Juan River where settlers had discovered gold for parcels of arid land to the east and west. Juanita, Manuelito, and the other members of the delegation opposed this exchange, and the deal was finally thwarted with the help of Thomas Keam, the famous Indian trader.

VOICES AND IMAGES

The voices of native peoples cannot be contained by photographic images; their stories cannot be suppressed; they guarantee tribal survivance. If we listen carefully, they remind us that we are intimately connected to the people we call Indians. Our relation is not solely one of history, but rather one of identity and meaning related to our own construction of Selves. Our fascination with the Indian as exotic Other plays on general processes accessed in the cultural construction of difference. We are who we are as Americans, in part, because of who we think they are. But there are other, less opposi-tional, ways to acknowledge difference; ways in which tolerance and mutual respect can play defining roles. These ways require looking beyond image to seek out the voices of individuals and honoring their lived experience.

The history of Native American-White relationships has been largely defined and controlled through manufactured images, and these images, not surprisingly, have served our purposes in the construction of our National identity. If we listen critically to the voices of Manifest Destiny and progress, we can begin to identify some of the contradictions between our professed democratic ideals of equal representation and our political actions which have systematically denied a voice to Native Americans. We can learn why we have constructed Native Americans as Noble Savages and as a Vanishing Race. And with this new knowledge, we can begin to appreciate why we must stop speaking for native peoples and start listening to them about their needs and desires for their lives and the lives of their children.

NOTES

1. I am writing this essay from the vantage point of a white male archaeologist who has worked closely with a number of Native American individuals and one Native American tribe. My ideas and research have been strongly influenced by these experiences.

2. Christopher M. Lyman, *The Vanishing Race and Other Illusions: Photographs of Indians by Edward S. Curtis.* (New York: Pantheon Books, 1982), p. 24.

3. Brian W. Dippie, *The Vanishing American: White Attitudes and U. S., Indian Policy,* (Middletown: Wesleyan University Press, 1982).

4. Theodore W. Taylor, *The Bureau of Indian Affairs* (Boulder: Westview Press, 1984).

5. See above, note 3, Dippie, p. 18.

6. Philip Freneau, "On the Civilization of the Western Aboriginal Country" (1822), in Lewis Leary, ed., *The Last Poems of Philip Freneau* (New Brunswick, New Jersey), pp. 69.

7. James Fenimore Cooper, *The Last of the Mohicans* (New York: Signet, 1962).

8. John Collier, "Office of Indian Affairs," Annual Report to the Secretary of the Interior, 1938 (Washington D. C., 1938), p. 209.

9. Theodore Roosevelt, Forward to the *North American Indian*.

10. Edward S. Curtis, Introduction to the *North American Indian*, (my emphasis).

11. Richard Pratt cited in Robert Utley, ed. Battlefield and Classroom: *Four Decades with the American Indian, the Memoirs of Richard H. Pratt*, (New Haven: Yale University Press, 1964), p. 266.

12. Tom Torlino was one of the principle informants of Washington Matthews, an anthropologist who worked with the Navaho. George Pepper, Pueblo Bonito, (New York: *Anthropological Papers of the American Museum of Natural History* Vol XXVII, 1920), p. 25.

13. Linda F. Witmer, *The Indian Industrial School: Carlisle, Pennsylvania* 1879–1918, (Carlisle: Cumberland County Historical Society, 1993), p. 115.

14. James C. Mitchell, Dec. 18, 1827, in Register of Debates in Congress, 20th Congress, 1st session, p. 821.

15. Don D. Fowler, *The Western Photographs of John K. Hilliers, Myself in the Water* (Washington D. C.: Smithsonian, 1989).

16. See above, note 2, Edward S. Curtis, cited in Christopher M. Lyman, p. 62.

17. See above, note 2, Lyman, pp. 62–78.

18. Red Cloud's speech to Secretary J. D. Cox dated June 7, 1870, cited in James C. Olsen, *Red Cloud and The Sioux Problem*, (Lincoln: University of Nebraska Press, 1965), p. 105.

19. William T. Hagan, *Quanah Parker, Comanche Chief*, (Norman: University of Oklahoma Press, 1993), p. 78.

20. Simon Ortiz, the Acoma poet, has written a poem entitled, "Juanita, wife of Manuelito" which was inspired by this photograph. Simon Ortiz, *Woven Stone* (Tuscon: University of Arizona Press, 1992).

21. Martin Link, ed. Navajo: *A Century of Progress 1868–1968*, (Window Rock: The Navajo Tribe, 1968), pp. 20–21.

Photographs

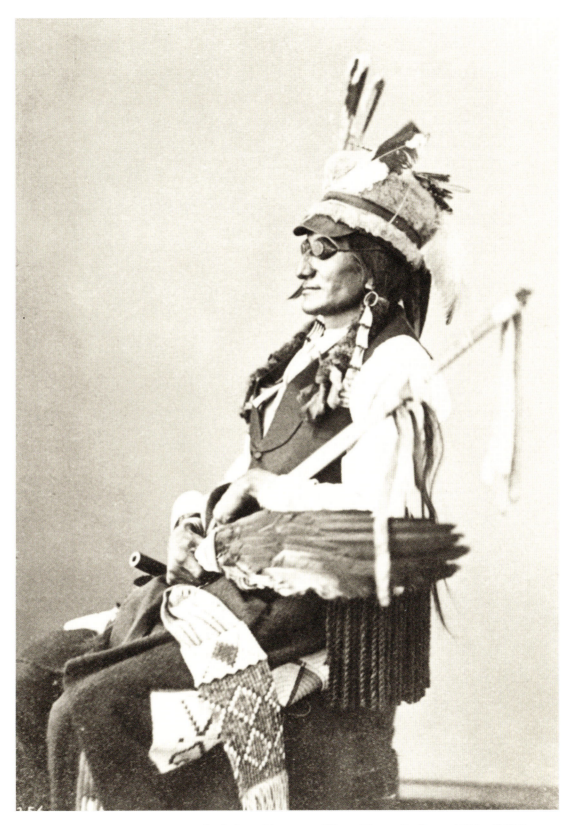

PLATE 1. Sitting Crow, Blackfoot Sioux. *William Henry Jackson, 1870s (#256).*

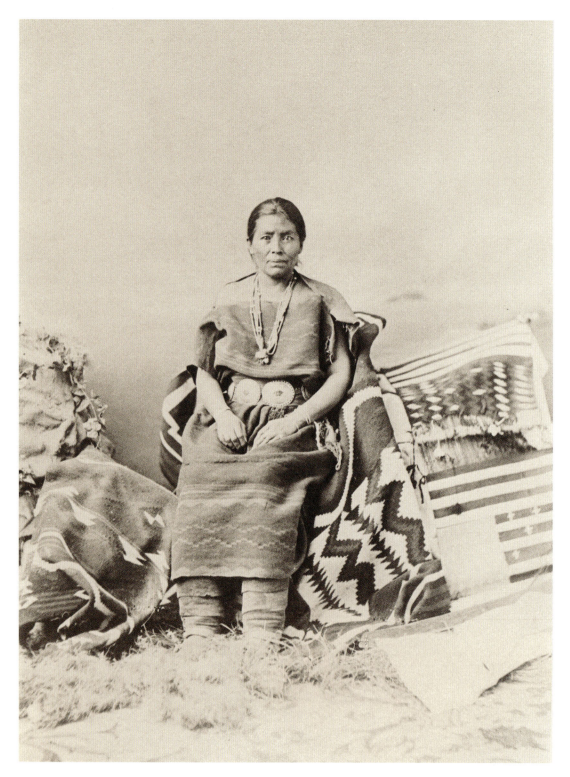

PLATE 2. Juanita Bahad, wife of Navajo tribal leader Manuelito.
William Henry Jackson, 1874.

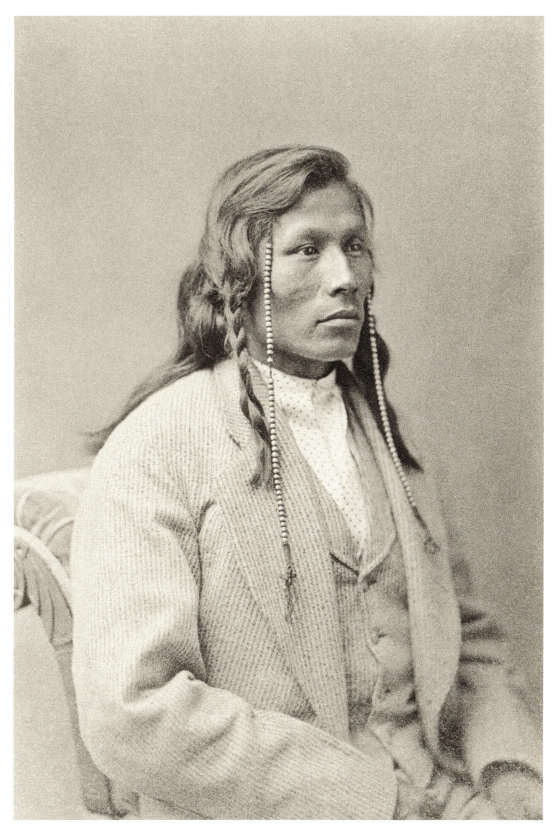

PLATE 3. "Running Face, Mandan." *William Henry Jackson, 1870s.*

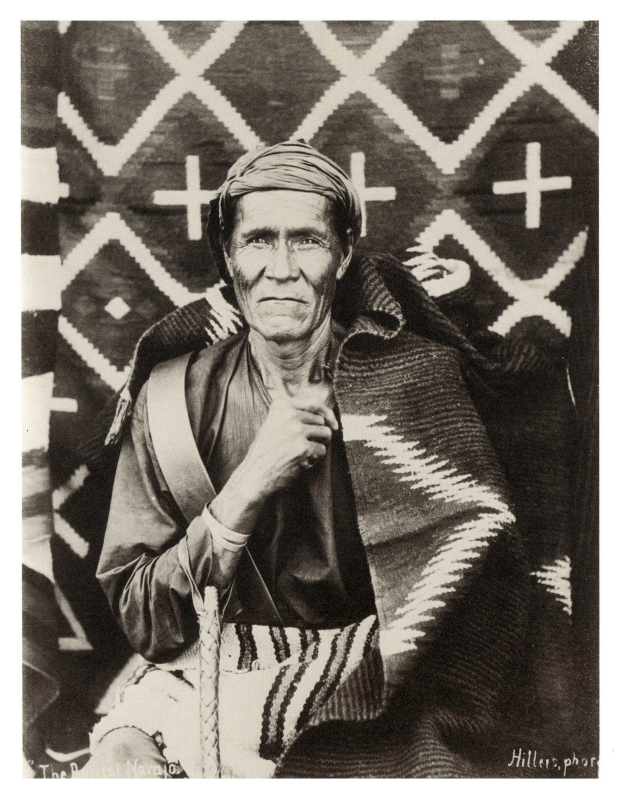

PLATE 4. "The Ancient Navajo." *John K. Hillers, 1870s.*

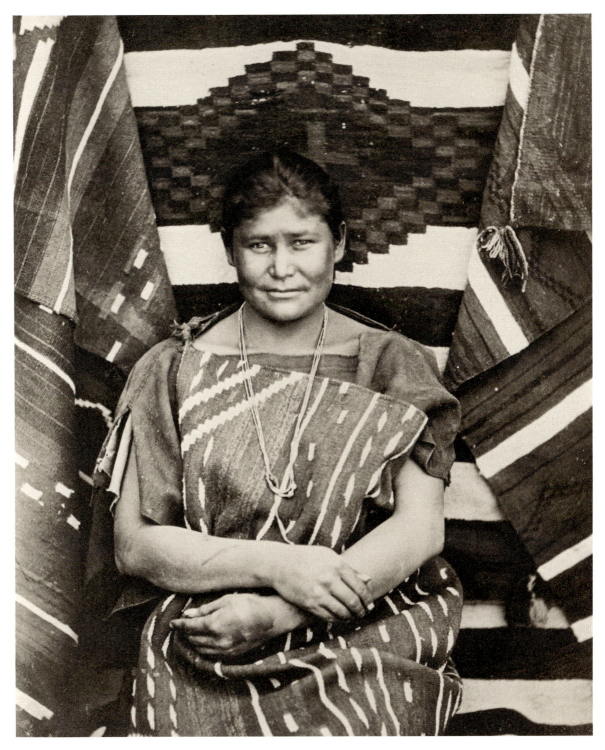

PLATE 5. "Hedipu, a Navajo Woman." *John K. Hillers, 1870s.*

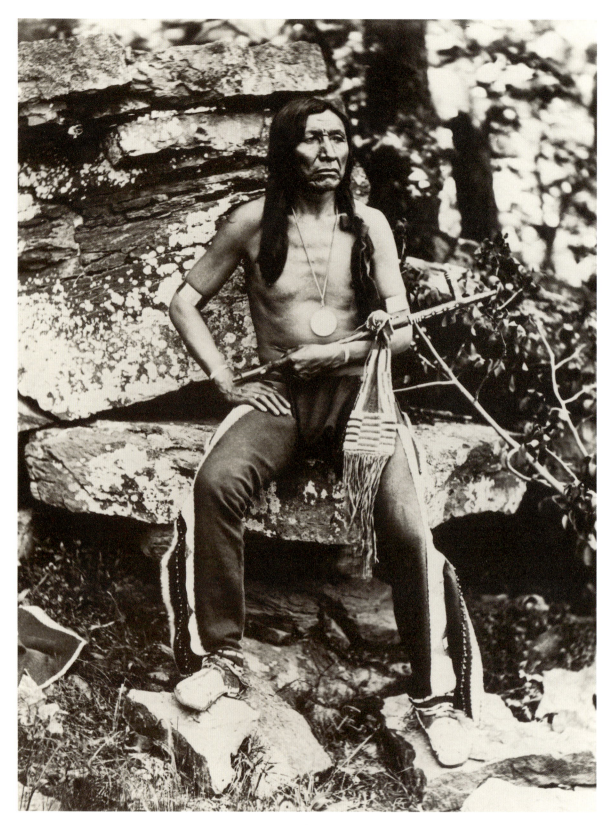

PLATE 6. Jicarilla Apache. *John K. Hillers, 1870s.*

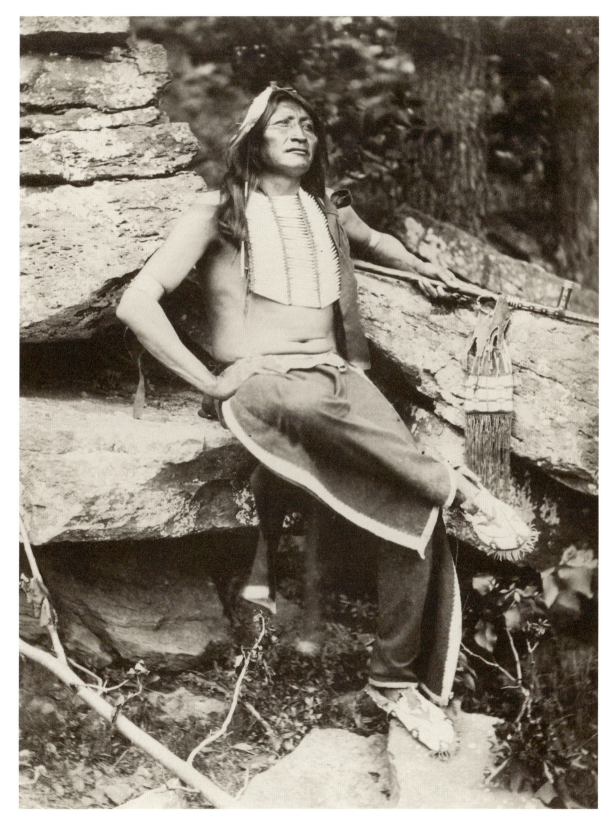

PLATE 7. Húch-i-vi, Jicarilla Apache. *John K. Hillers, 1870s.*

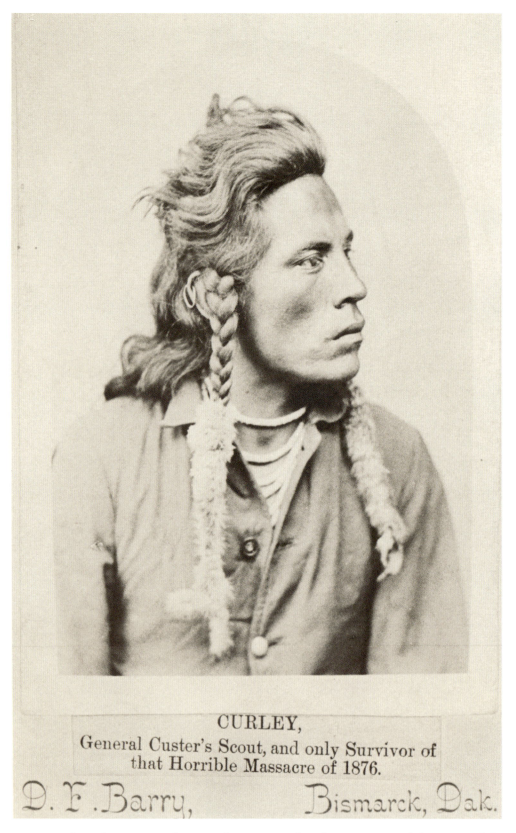

CURLEY,
General Custer's Scout, and only Survivor of
that Horrible Massacre of 1876.

D. F. Barry, Bismarck, Dak.

PLATE 8. "Curley, General Custer's Scout and only Survivor of that Horrible
Massacre of 1876." Bismarck, North Dakota.
D. F. Barry, from the Stephens Collection.

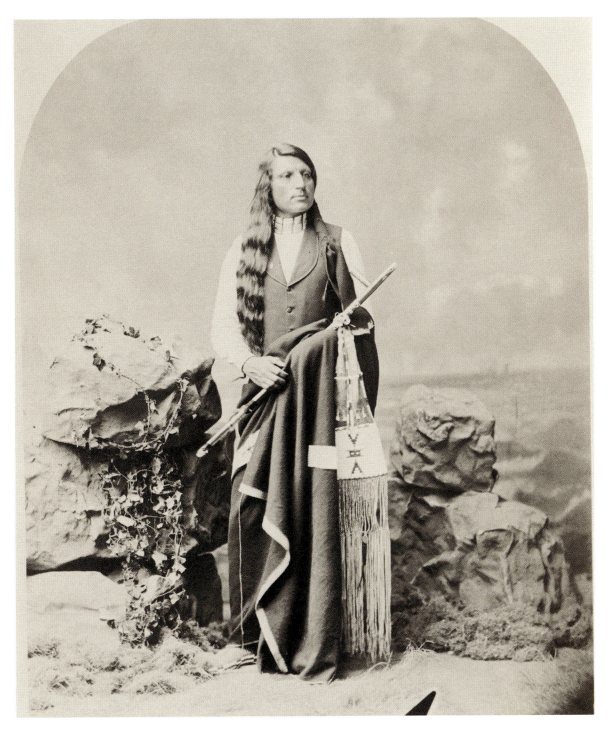

PLATE 9. Red Shirt, Dakota. *C. M. Bell, Washington, D. C., 1880s.*

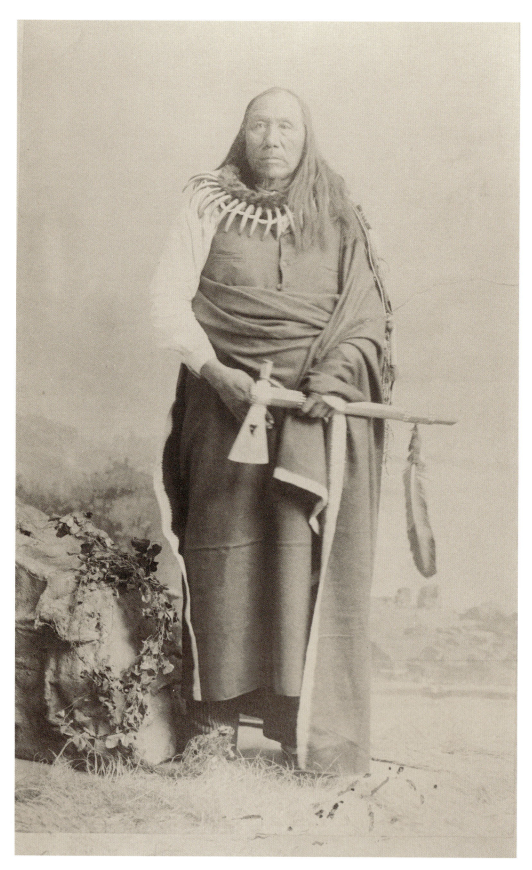

PLATE 10. Standing Buffalo. *C. M. Bell, Washington, D. C., 1880s.*

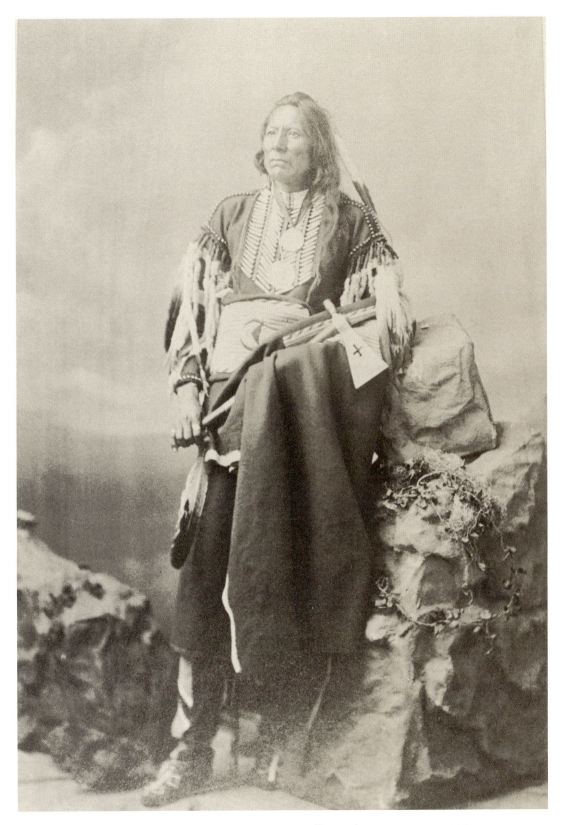

PLATE 11. Dakota Sioux. *C. M. Bell, Washington, D. C., 1880s.*

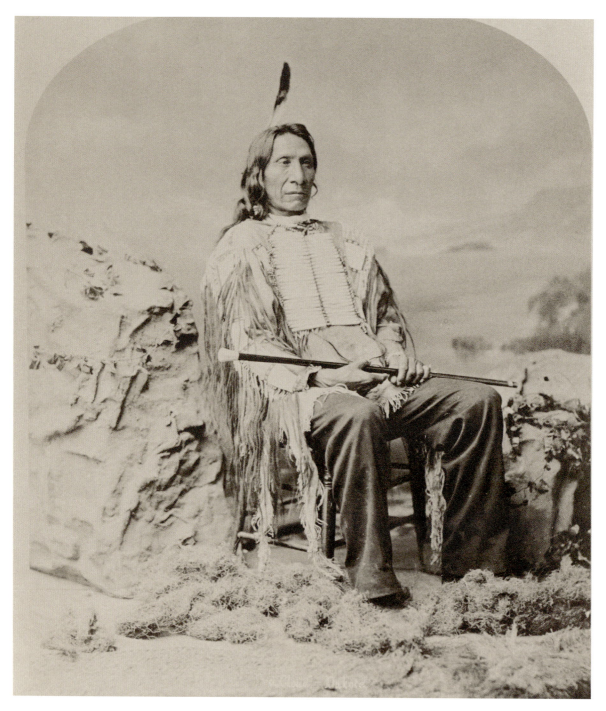

PLATE 12. Red Cloud, Dakota. *C. M. Bell, Washington, D. C., 1880.*

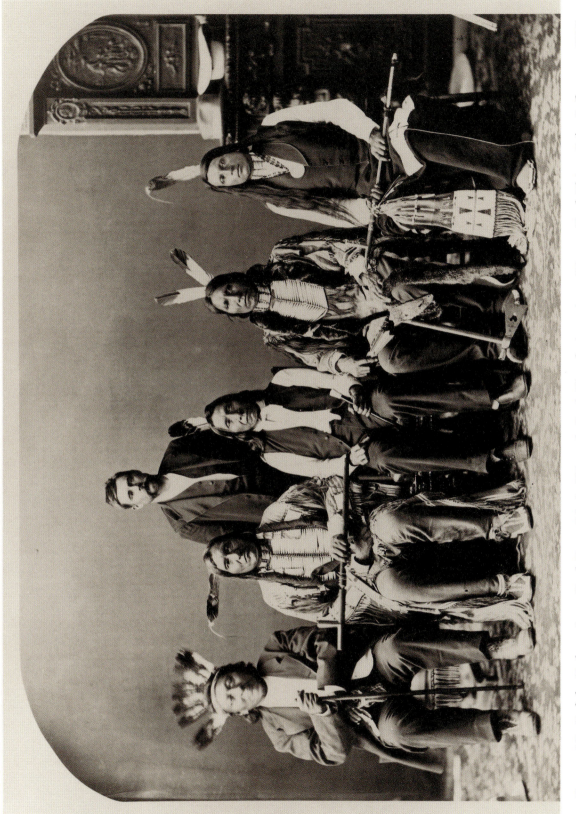

PLATE 13. Oalala Delegation: Red Dog, Little Wound, Red Cloud, American Horse, Red Shirt. *John Bridgeman, 1870.*

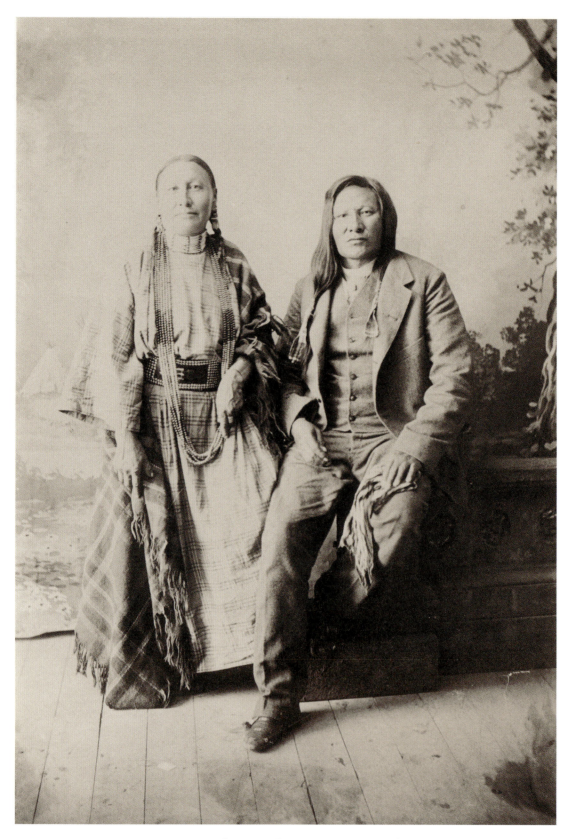

PLATE 14. Standing Rock Agency — Typical Sioux.
Gilbert Gaul, 1890, Donaldson Collection-U. S. Census of 1890.

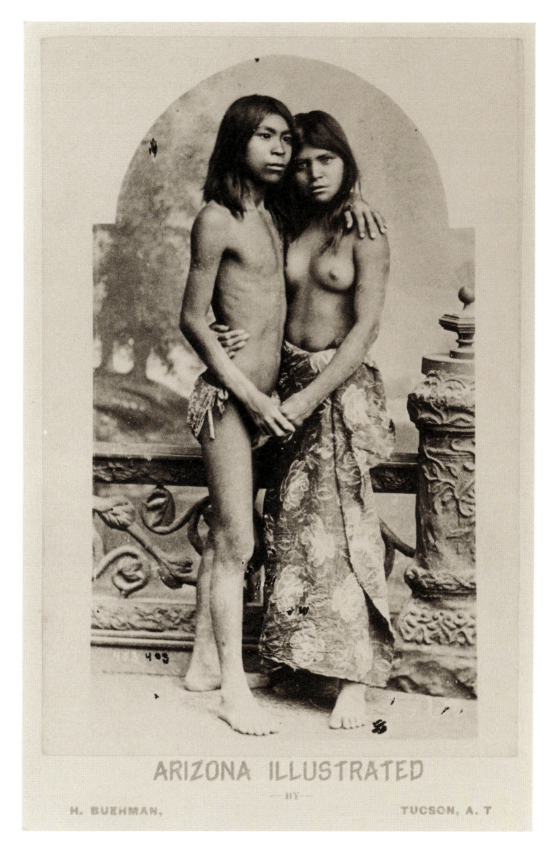

ARIZONA ILLUSTRATED
—BY—
H. BUEHMAN, TUCSON, A. T

PLATE 15. Pima Apache. *H. Buehman, Tucson, Arizona Territory, 1891,*
Donaldson Collection-U. S. Census of 1890 (#405).

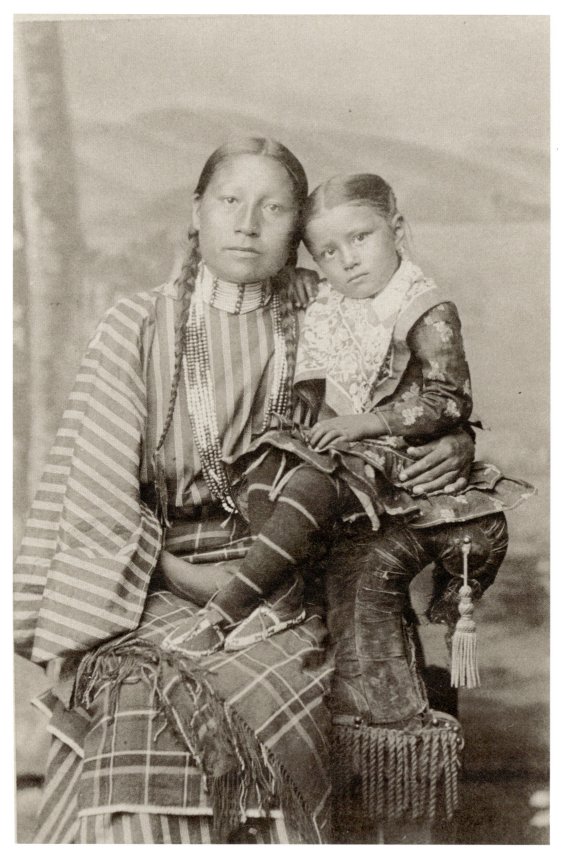

PLATE 16. South Cheyenne. *Stephens Collection.*

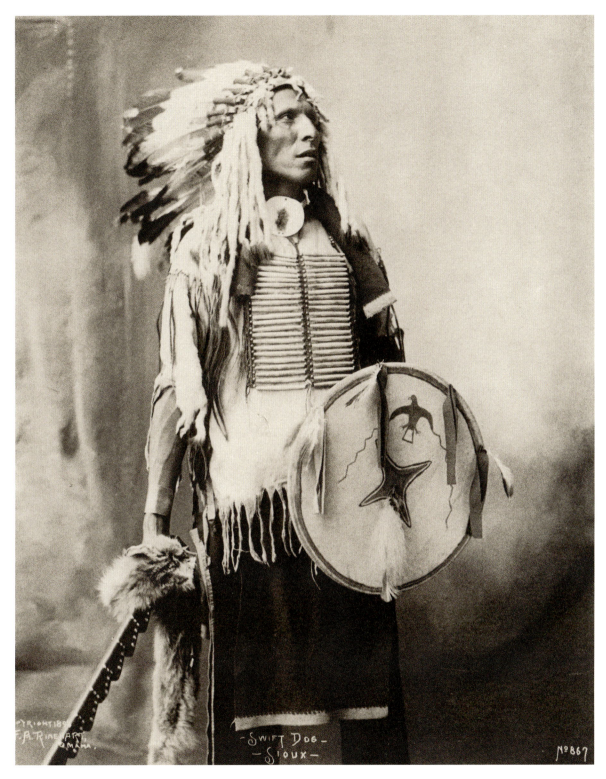

PLATE 17. Swift Dog, Sioux. *F. A. Rinehart, Omaha, Nebraska, 1898 (#867).*

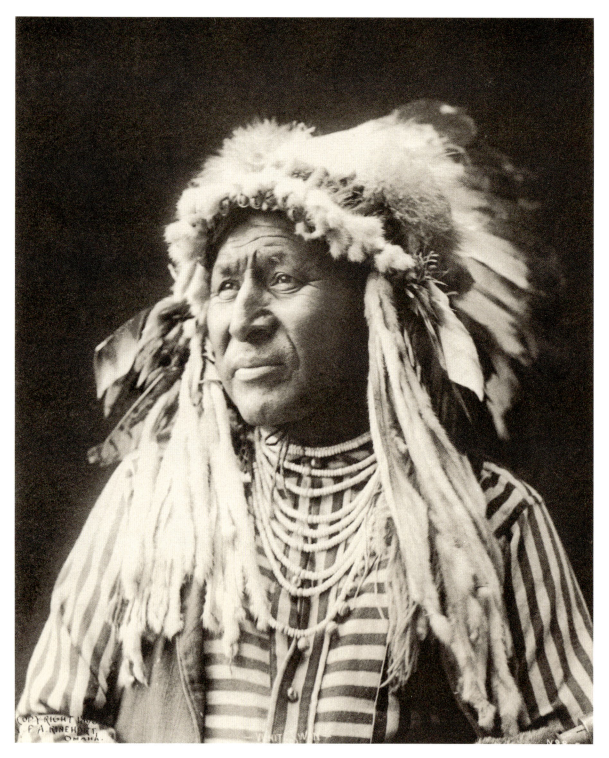

PLATE 18. "White Swan, Crow." *F. A. Rinehart, Omaha, Nebraska, 1898 (#815).*

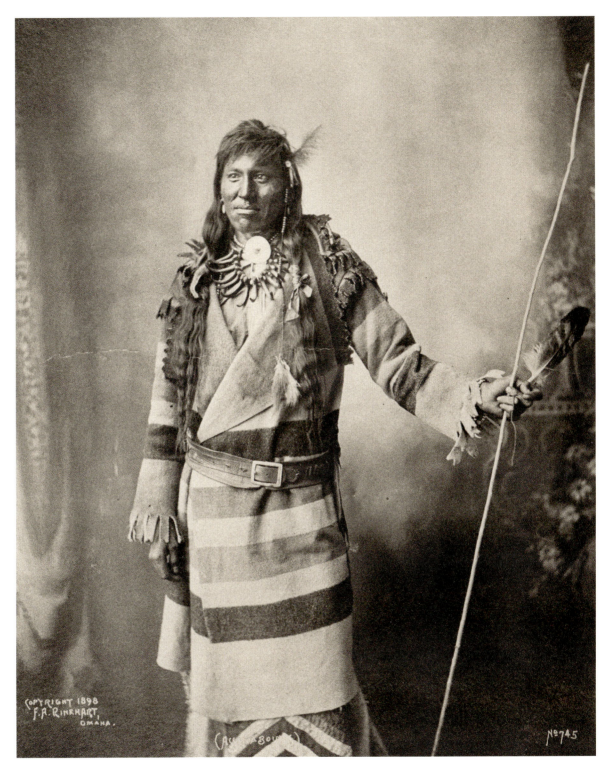

PLATE 19. Assinaboines. *F. A. Rinehart, Omaha, Nebraska, 1898 (#745).*

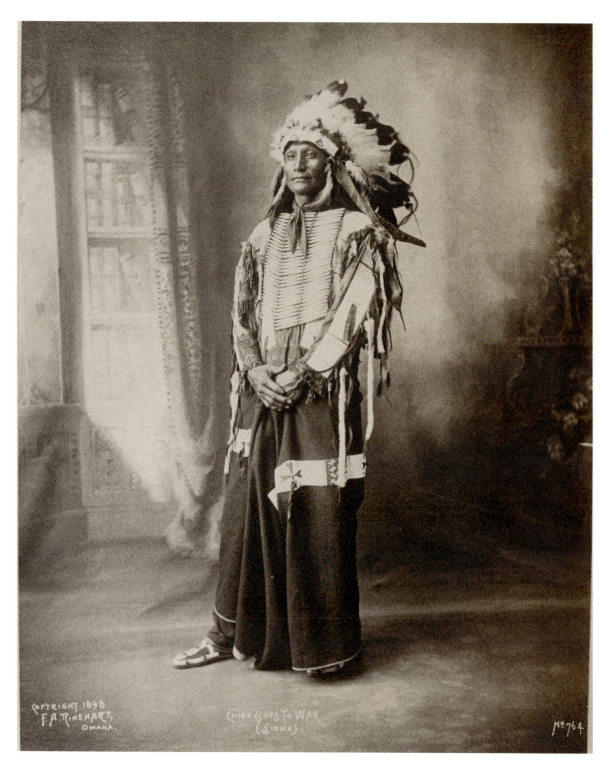

PLATE 20. "Chief Goes to War (Sioux)." *F. A. Rinehart, Omaha, Nebraska, 1898 (#764).*

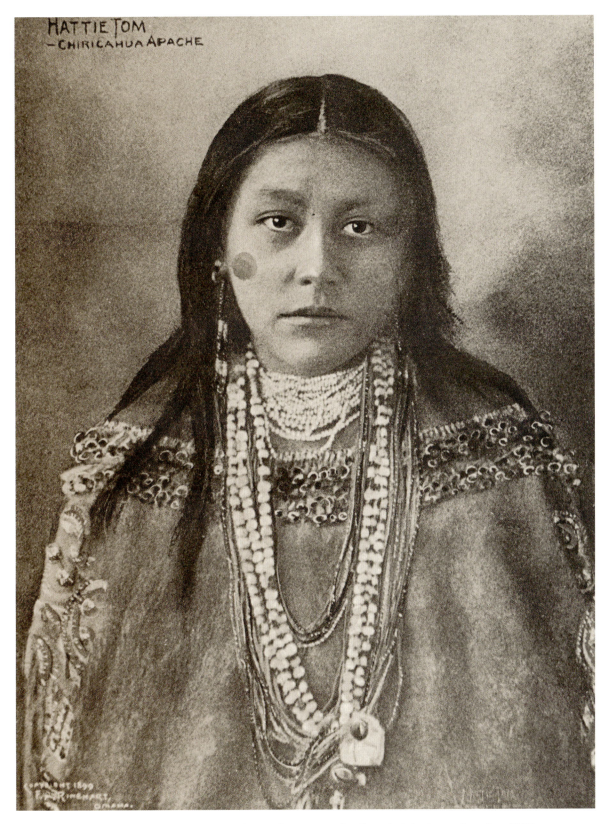

PLATE 21. "Hattie Tom. Chiricahua Apache." *F. A. Rinehart, Omaha, 1899.*

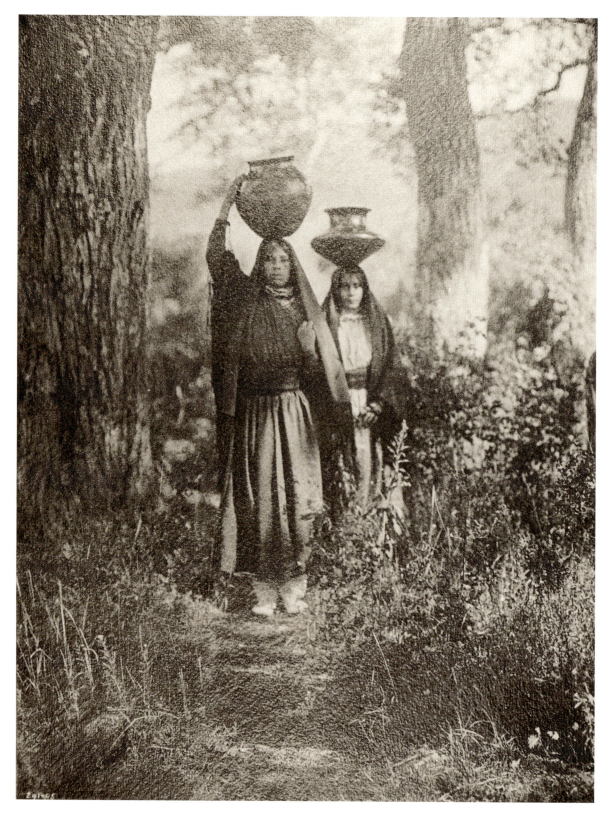

PLATE 22. "Taos Water Girls." *Edward S. Curtis, Seattle, Washington, 1905 (#291-05).*

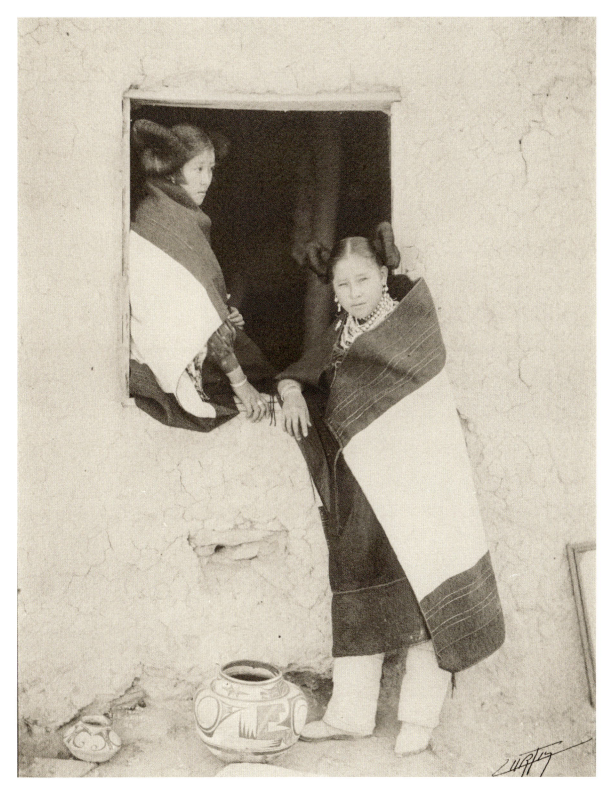

PLATE 23. "Hopi Girls in Window." *Edward S. Curtis, Seattle Washington, 1900 (#88).*

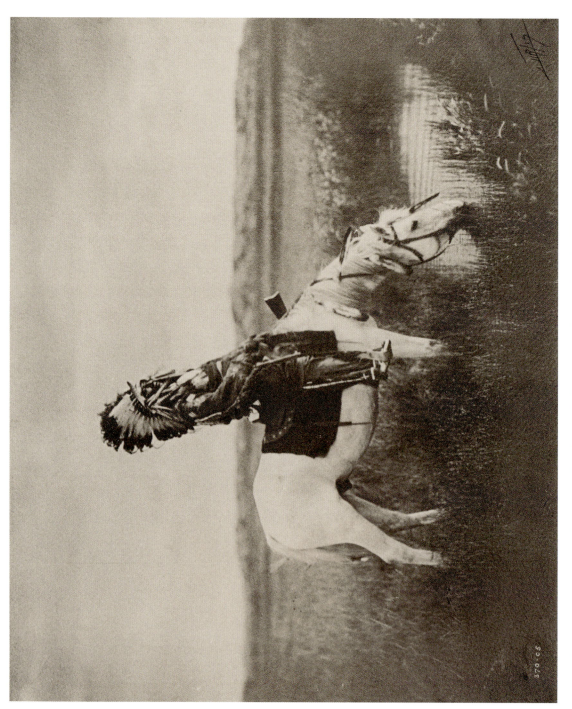

PLATE 24. "An Oasis in the Badlands." *Edward S. Curtis, Seattle, Washington, 1905* (#370-05).

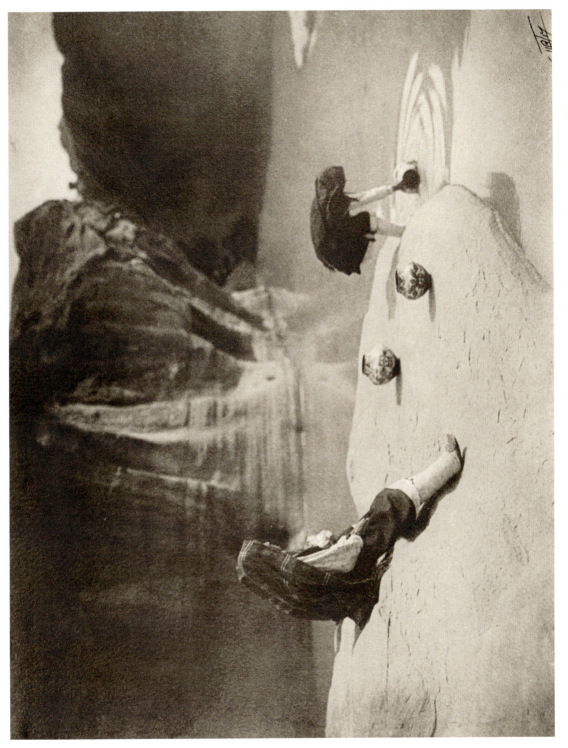

PLATE 25. "At the Old Well at Acoma." *Edward S. Curtis, Seattle, Washington, 1905 (#575-04).*

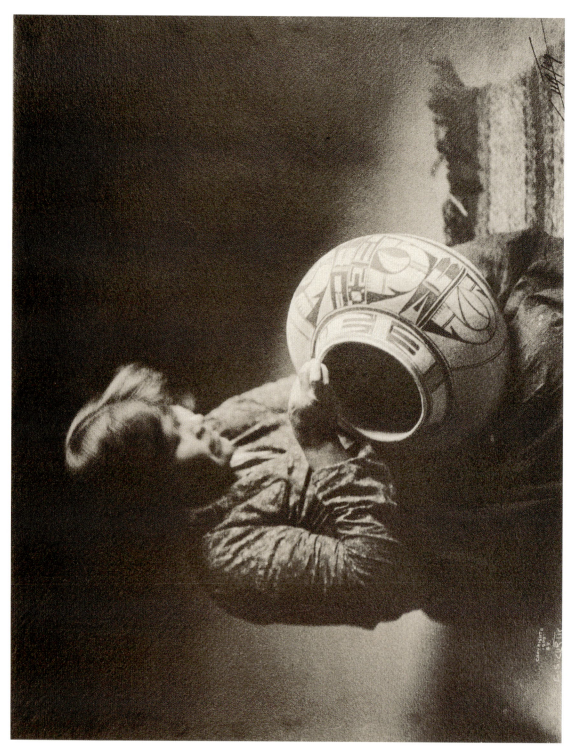

PLATE 26. "The Potter (Nampeyo, Hopi)." *Edward S. Curtis, Seattle, Washington, 1909.*

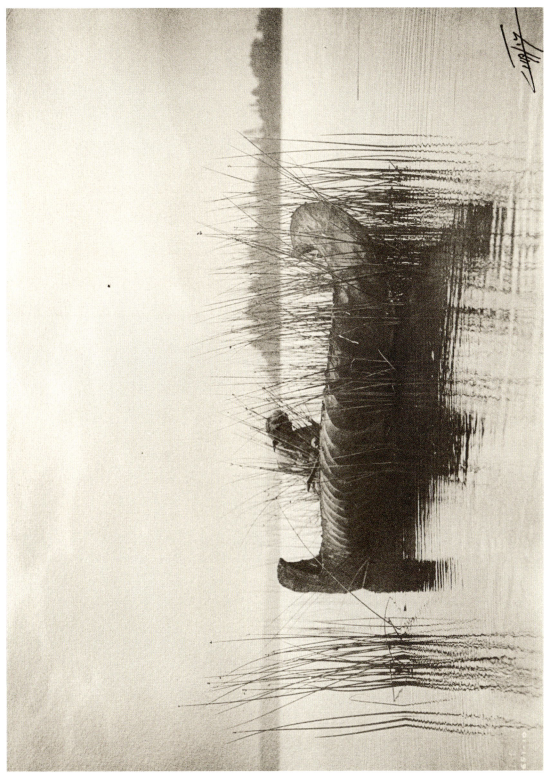

PLATE 27. "The Rush Gatherer—Kutenai." *Edward S. Curtis, Seattle, Washington, 1905 (#651-10).*

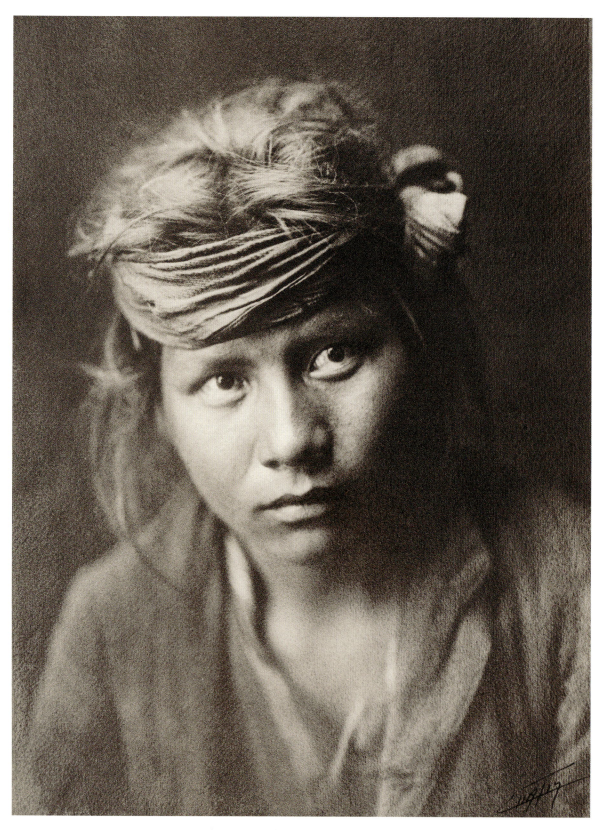

PLATE 28. "A Son of the Desert—Navajo."
Edward S. Curtis, Seattle, Washington, 1904 (#182-04).

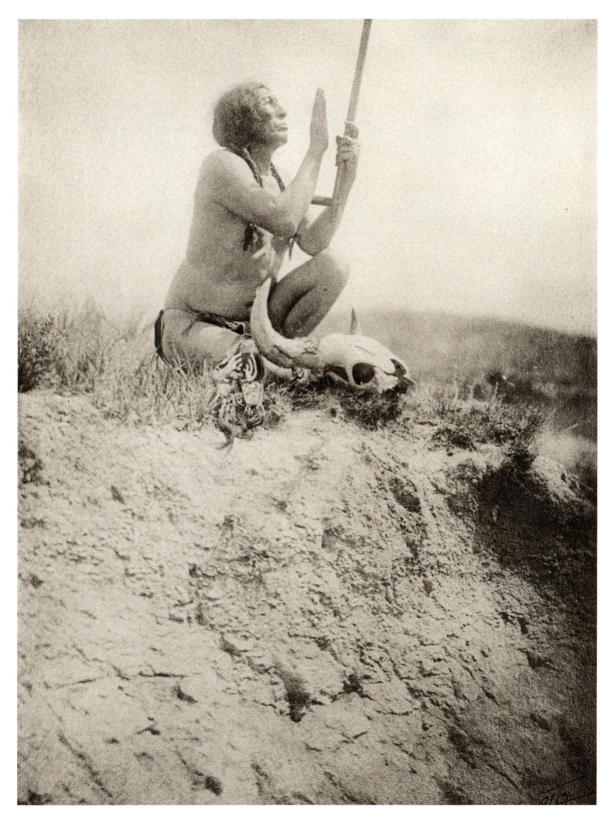

PLATE 29. "Prayer to the Great Mystery (Slow Bull, Sioux)"
Edward S. Curtis, Seattle, 1907.

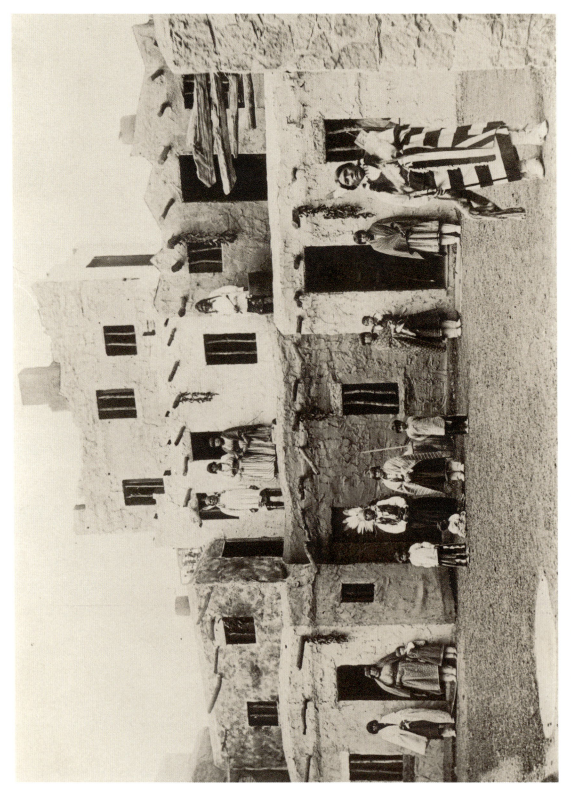

PLATE 30. "Cliff Dwellers Houses." *Jessie Tarbox Beals, St. Louis, Missouri, 1905 (#900).*

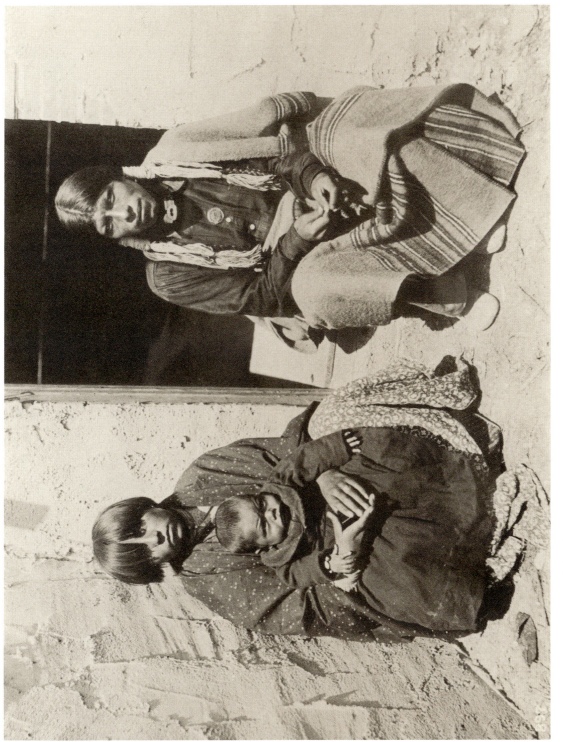

PLATE 31. "Cliff Dwellers Family." *Jessie Tarbox Beals, St. Louis, Missouri, 1905 (#897).*

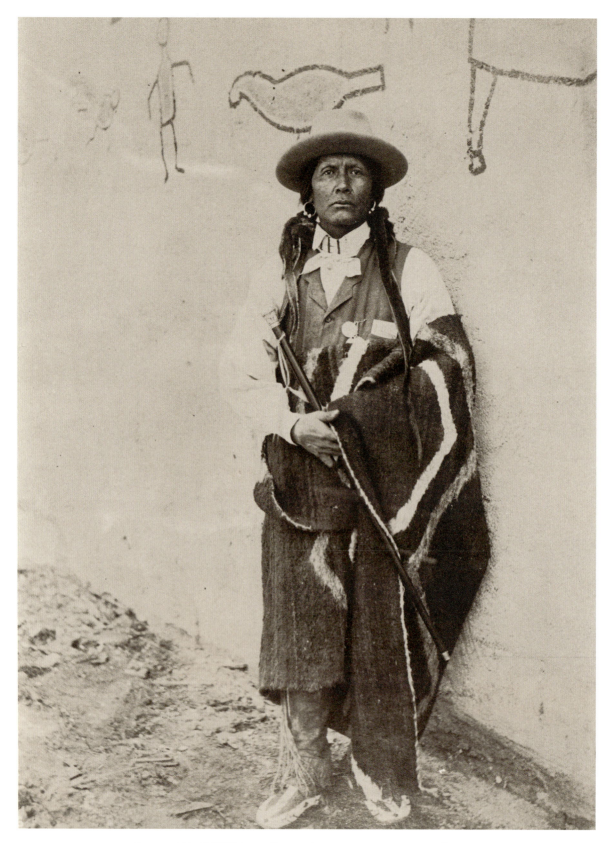

PLATE 32. "Cliff Dwellers, Governor Ramos Ajuleta."
Jessie Tarbox Beals, St. Louis, Missouri, 1905 (#896).

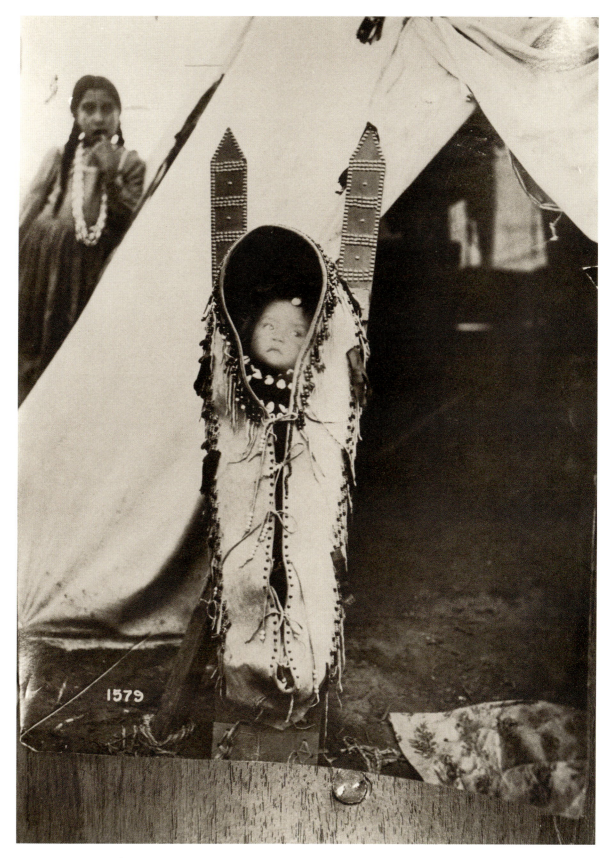

PLATE 33. Cheyenne Papoose in Cradle. *Jessie Tarbox Beals, St. Louis, Missouri, 1905.*

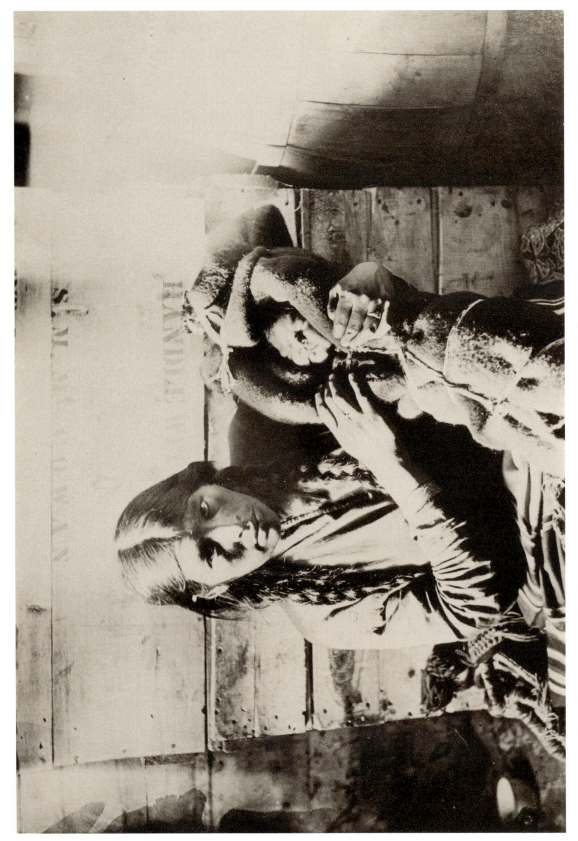

PLATE 34. Sioux baby, only six hours old, and her mother. *Jessie Tarbox Beals, St. Louis Missouri, 1905 (#1506).*

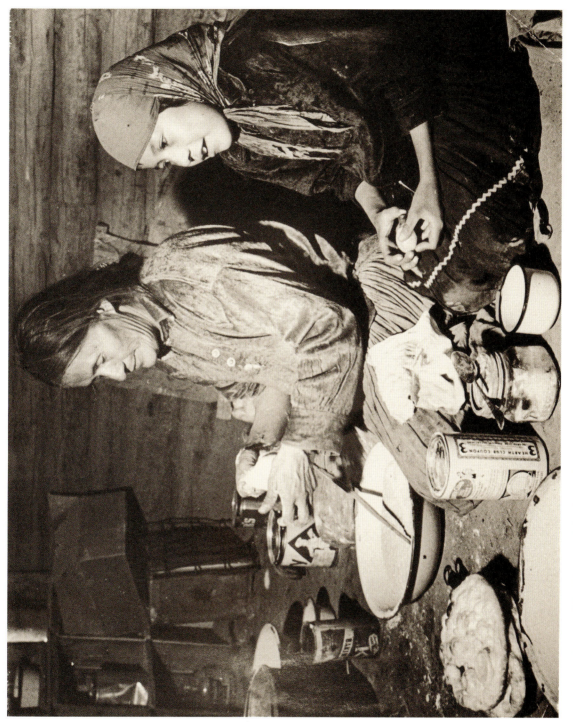

PLATE 35. *Photo #26. John Collier, Jr., Taos, New Mexico, 1940s. Gift of Mrs. Martin Meyerson.*

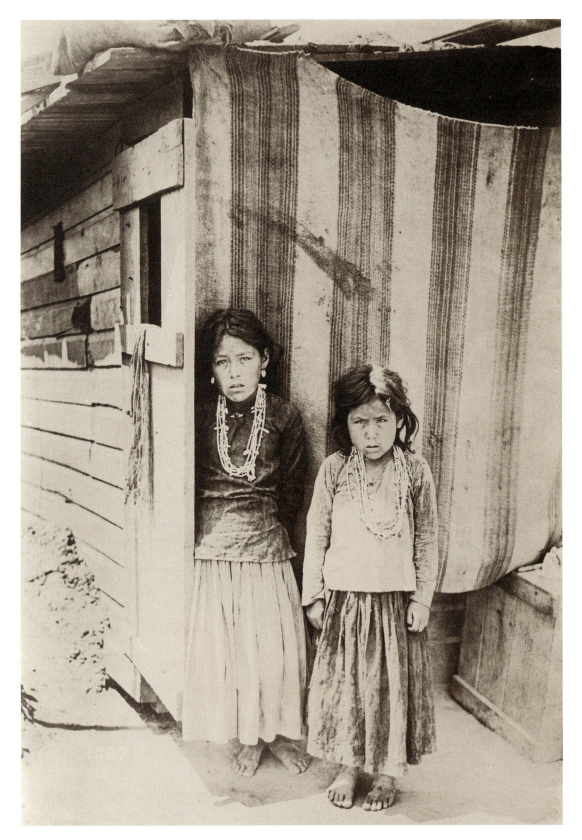

PLATE 36. Navajo Girls, seven and eight.
Jessie Tarbox Beals, St. Louis, Missouri, 1905 (#1567).

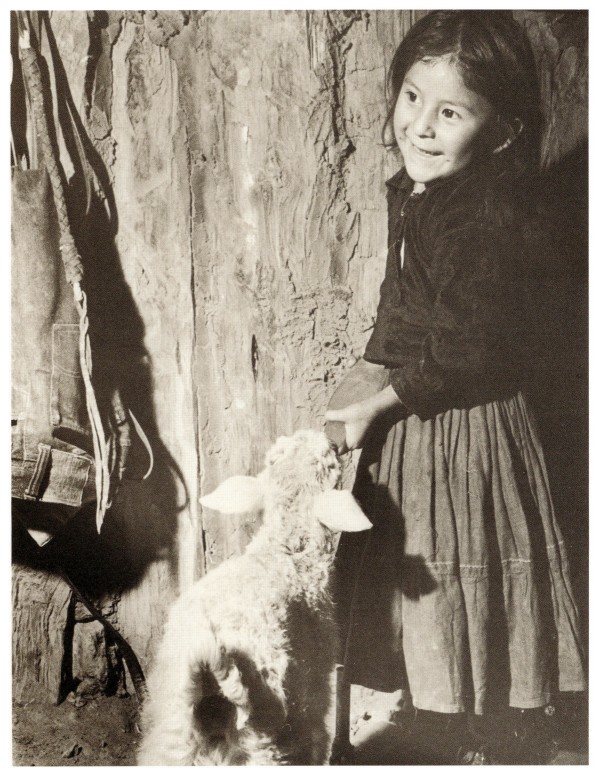

PLATE 37. Navajos rarely control the breeding season, so lambs are often
born in the winter when icy weather makes their survival hazardous.
In such cases, the lambs are brought into the hogan to protect them from the weather.
Burnt Corn Valley, ten miles north of Pinion, Arizona.
John Collier, Jr., Taos, New Mexico, 1940s. Gift of Mrs. Martin Meyerson.

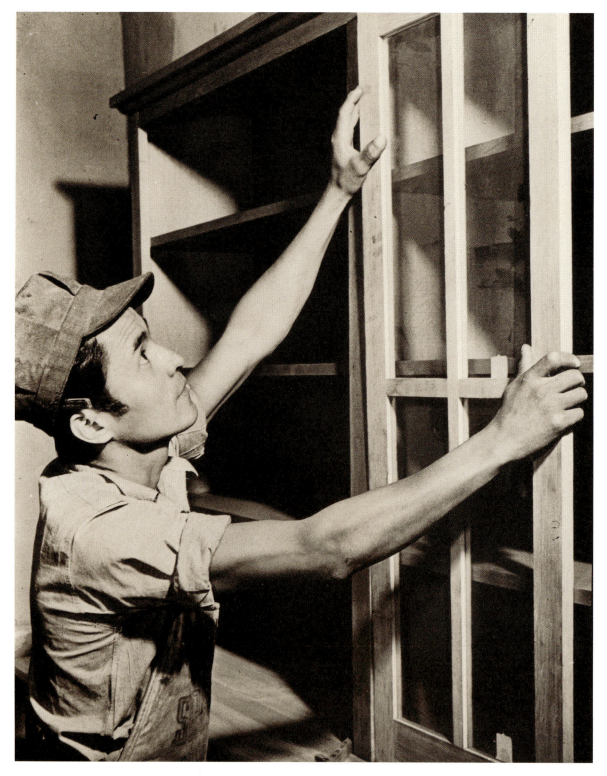

PLATE 38. William Dayman, returned Navajo veteran, makes his living doing carpentry and hauling timber in the truck he bought with the money saved from his G.I. wages. *John Collier, Jr., Taos, New Mexico, 1940s (#387). Gift of Mrs. Martin Meyerson.*

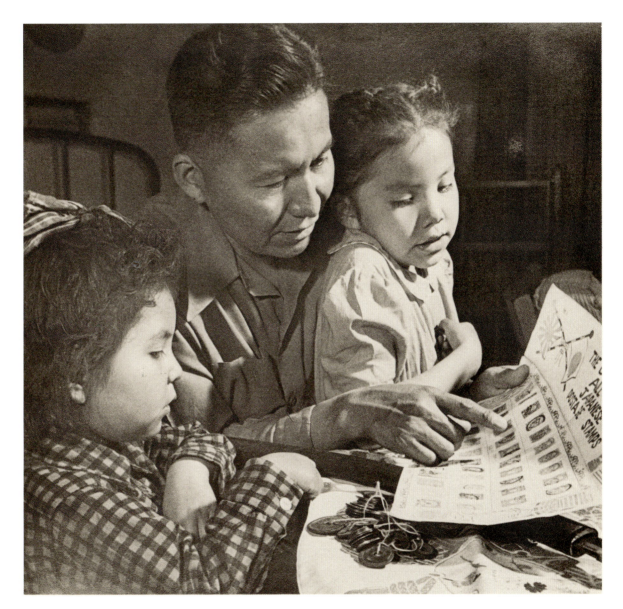

PLATE 39. Robert Tallsalt was a "talker" in the Marine Corps. in the Pacific relaying messages in Navajo to and from front line positions. He is showing his daughters, Ruby and Bobby, some of the souvenirs he brought back from Japan.
John Collier, Jr., Taos, New Mexico, 1940s (#352). Gift of Mrs. Martin Meyerson.

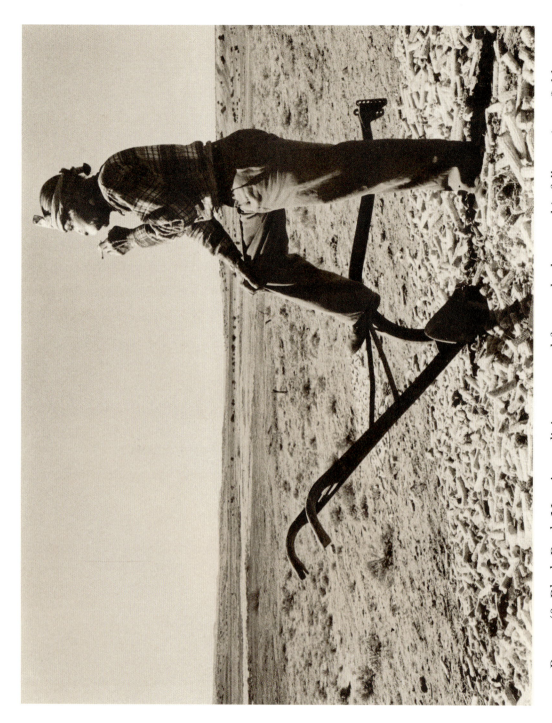

PLATE 40. Black Rock Navajo medicine man and farmer, looks over his fallow winter fields in anticipation of a fine year of agriculture. Near Wide Ruins, Arizona. *John Collier, Jr., Taos, New Mexico, 1940s (#83). Gift of Mrs. Martin Meyerson.*

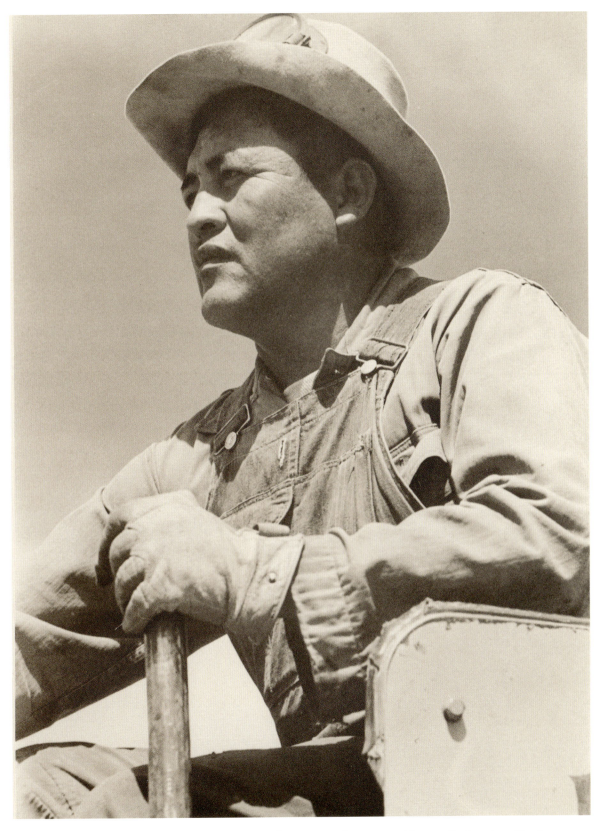

PLATE 41. Enos Tsiniminni, tractor driver, on the Many Farms Irrigation Project
in the Chinle Valley, Arizona.
John Collier, Jr., Taos, New Mexico, 1940s (#414). Gift of Mrs. Martin Meyerson.

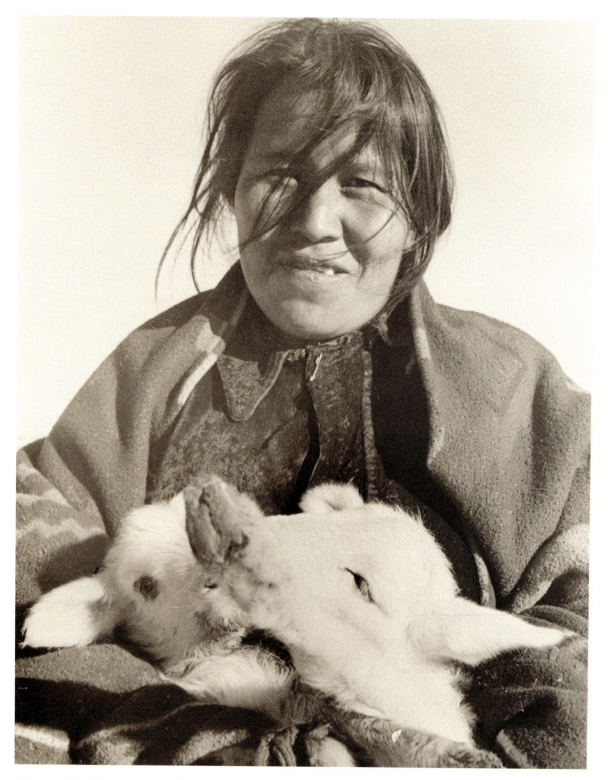

PLATE 42. Photo #15. *John Collier, Jr., Taos, New Mexico, 1940s. Gift of Mrs. Martin Meyerson.*

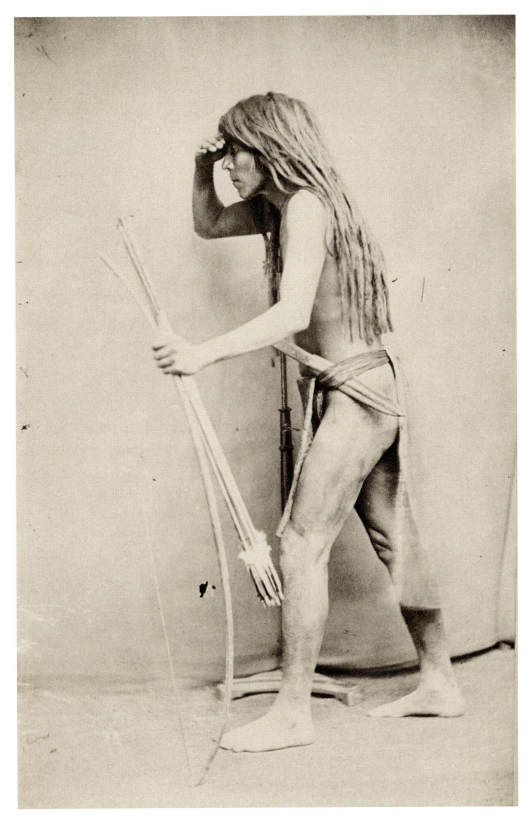

PLATE 43. Yuma Indian, Arizona. *E. A. Bonine, Pasadena, California.*

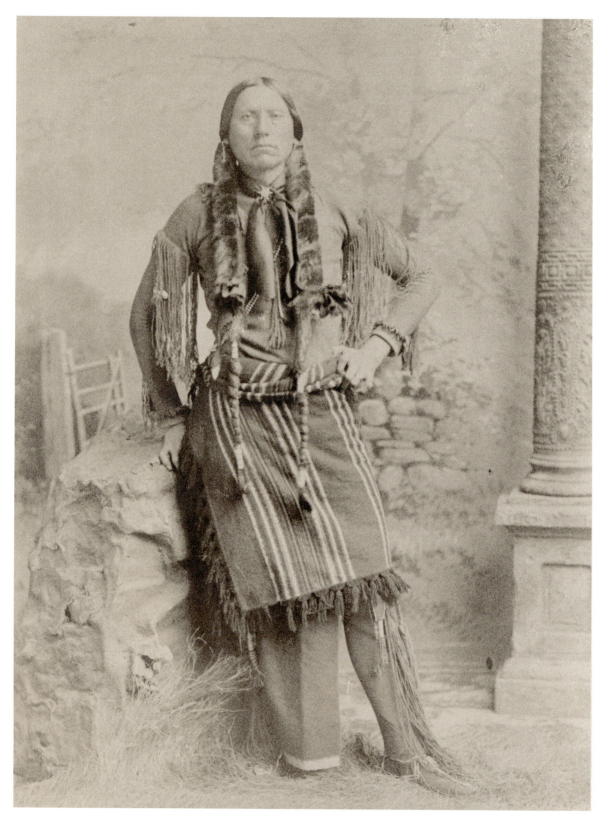

PLATE 44. Quanah Parker. *C. M. Bell, Washington, D. C., 1880s.*

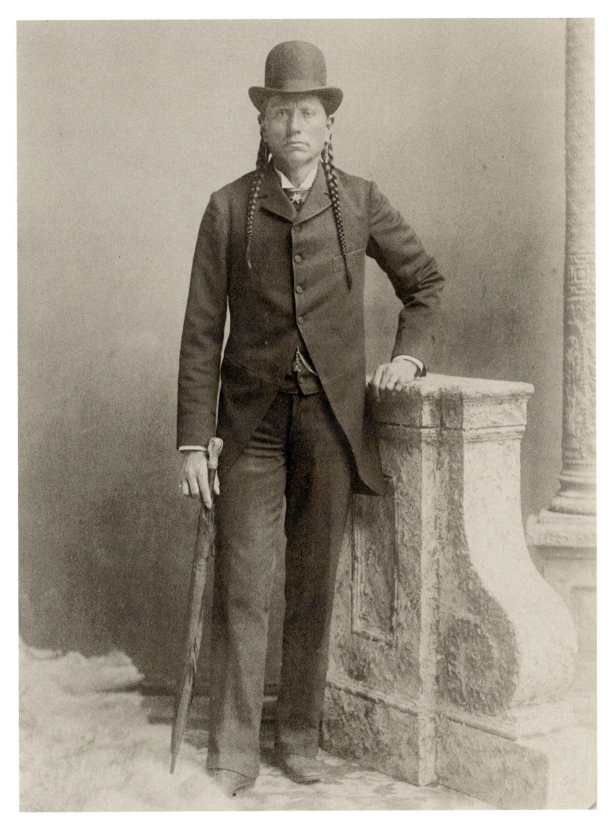

PLATE 45. Quanah Parker. *C. M. Bell, Washington, D. C., 1880s.*

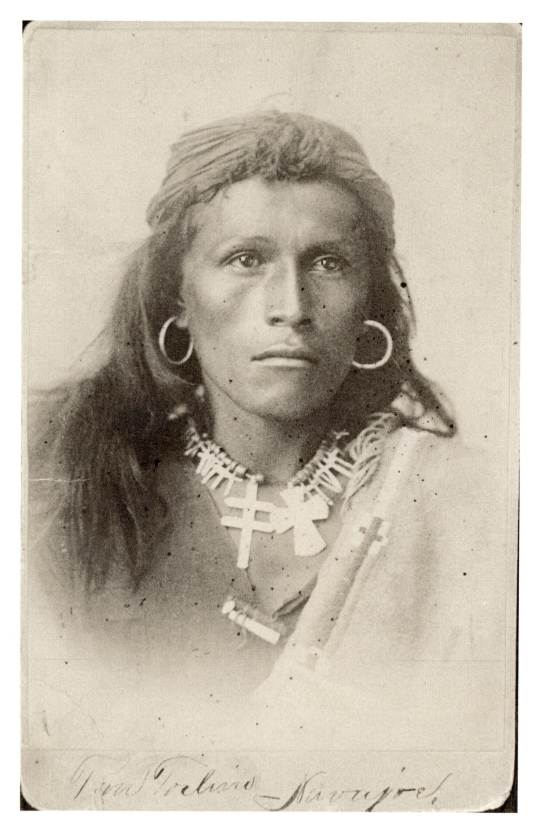

PLATE 46. Tom Torlino, Navajo, on entry to Carlisle School, Carlisle, Pennsylvania.
J. N. Choate, Carlisle, Pennsylvania, before 1882.

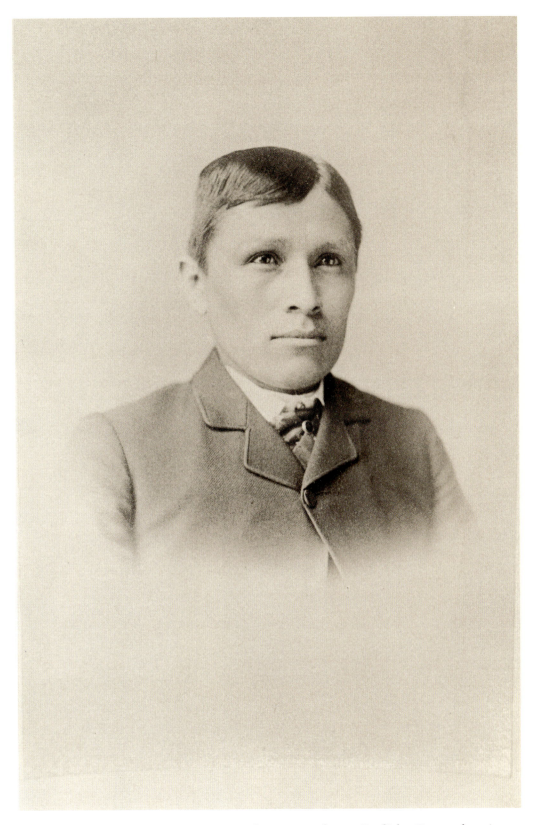

PLATE 47. Tom Torlino, Navajo, three years later, Carlisle, Pennsylvania.
J. N. Choate, Carlisle, Pennsylvania, after 1885.

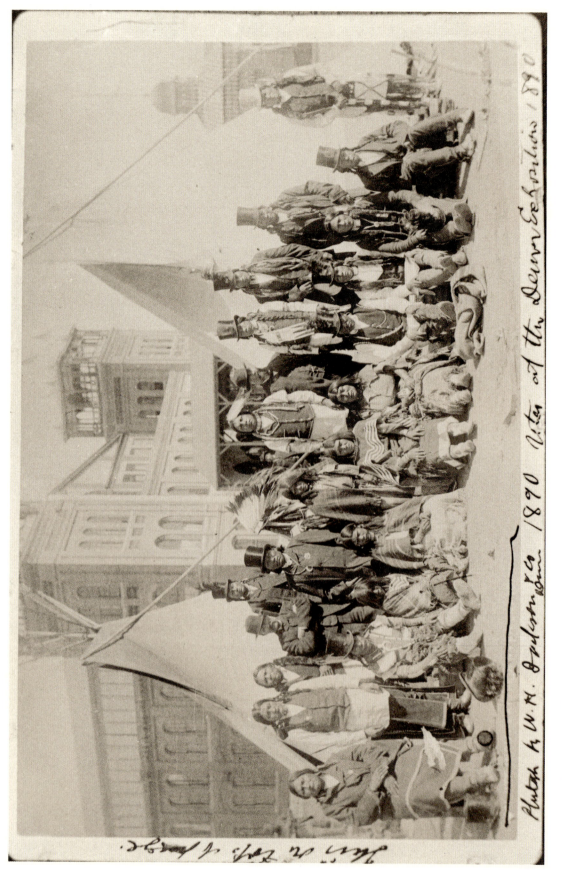

PLATE 48. Utes at the Denver Exposition, Colorado, 1890. *William Henry Jackson, Denver, Colorado, 1890.*